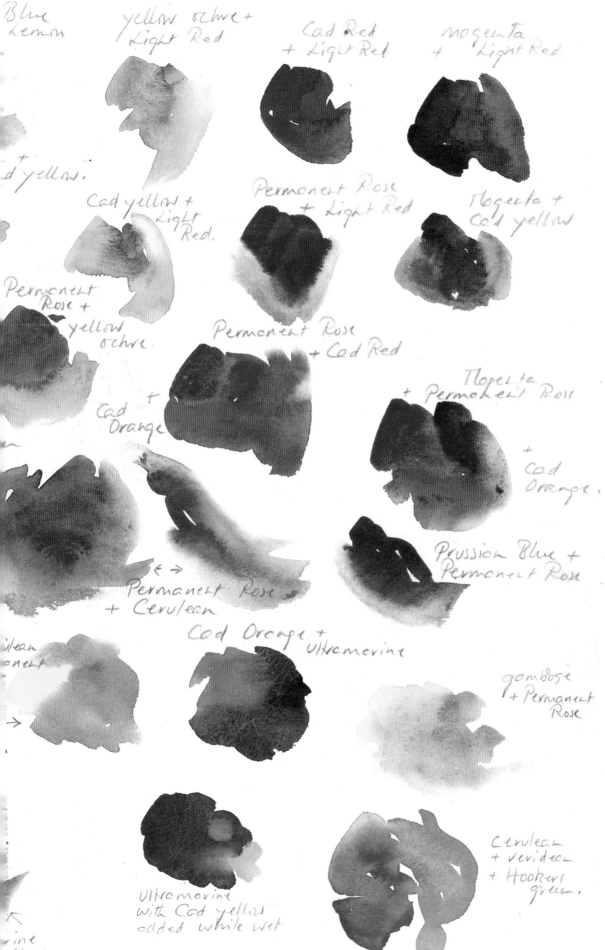

Blue
Lemon

yellow ochre +
Light Red

Cad Red
+ Light Red

magenta
+ Light Red

d yellow.

Cad yellow +
Light
Red.

Permanent Rose
+ Light Red

Magenta +
Cad yellow

Permanent
Rose +
yellow
ochre.

Permanent Rose
+ Cad Red

Magenta
+ Permanent Rose

Cad
Orange
+

+
Cad
Orange.

Prussian Blue +
Permanent Rose

Permanent Rose
+ Cerulean

Cad Orange +
Ultramarine

gamboge
+ Permanent
Rose

Ultramarine
with Cad yellow
added while wet

Cerulean
+ viridian
+ Hookers
green.

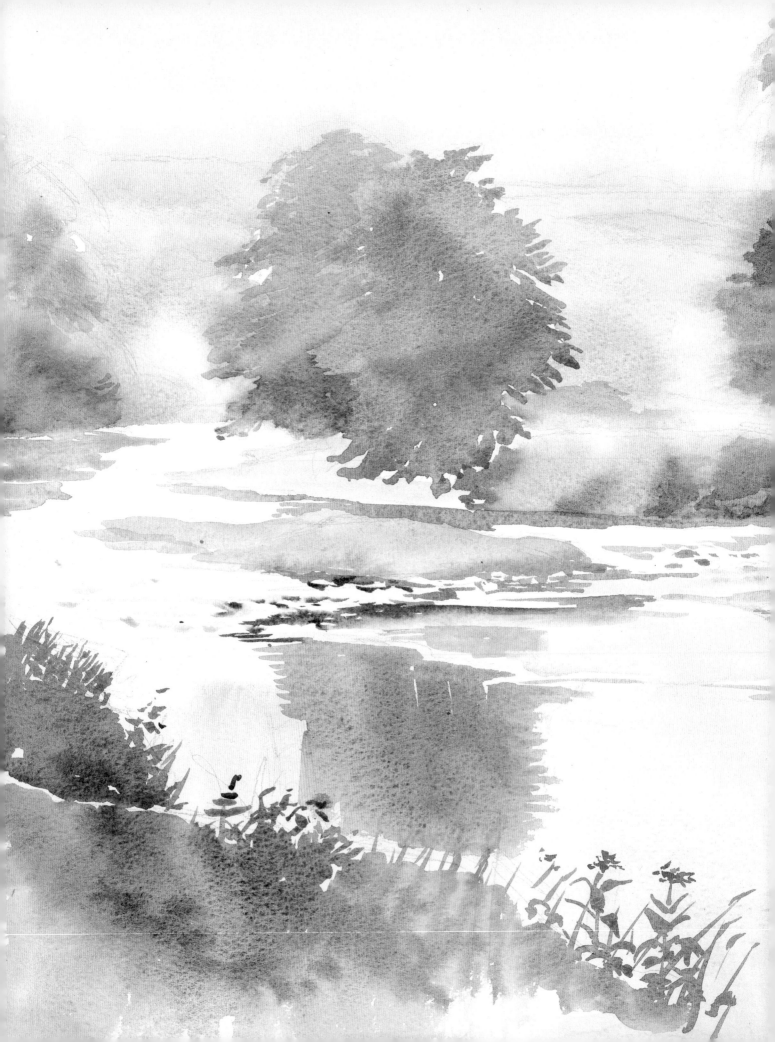

Watercolour Painting with Karen Simmons

B.T. Batsford Ltd, London

K.
Karen Simmons

To my late husband, Stanley Simmons, who would have enjoyed seeing this book come to fruition.

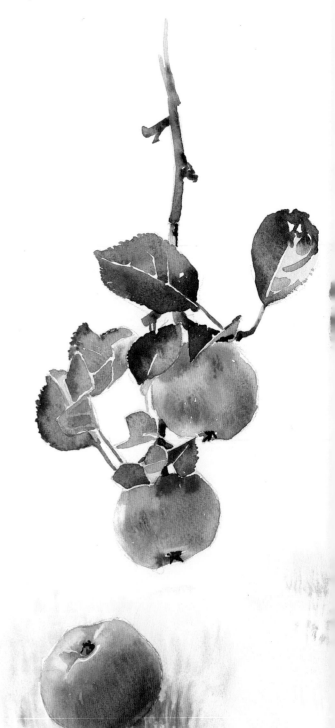

With heartfelt thanks to Roz Dace, whose professional guidance has been invaluable. Also to Shirley Price and my son Rupert Simmons for their help and support.

Karen Simmons demonstrates her watercolour techniques in two videos entitled *Flower Painting* and *Gardens in Watercolour*. Both videos are available from APV Films, 6 Alexandra Square, Chipping Norton, Oxon OX7 5HL (Tel: 0608 641798).

First published 1993
© Karen Simmons 1993
Reprinted 1995

Typeset by Servis Filmsetting Ltd, Manchester and printed in Hong Kong

Published by
B.T. Batsford Ltd
4 Fitzhardinge Street
London W1H 0AH

British Library Cataloguing-in-Publication Data.
A catalogue record for this book is available from the British Library.

ISBN 0 7134 7105 0

Front cover
*Detail of **Autumn berries**
(the full painting can be seen on pages 84–5)*

Back cover
Bougainvillaea
19¾ × 16 in (50 × 40·5 cm)

Pages 2–3
Dawn on the Tamar
16 × 19¾ in (40·5 × 50 cm)

Contents

Apple boughs
19¾ × 16 in (50 × 40·5 cm)

K.
Karen Simmons

Foreword

Teaching watercolour painting is a far from easy occupation, which involves putting across theories – many of which cause confusion by conflicting with each other – and complicated techniques that require skill, judgement, planning and often a large slice of luck. Karen's methodical and analytical approach sensitively guides the student along the way, explaining each stage of the process clearly by breaking down daunting passages into easily manageable chunks. This is absolutely vital with herbaceous borders, for example, where planning and simplification are essential. Maintaining a sense of unity within such a riot of colour is something of an anachronism, but Karen achieves this amazing feat with judicious application of lovely clean washes, or blushes, as she likes to refer to them. Note how she builds up her picture with considered care, yet still manages to inject a gloriously poetic flourish to set off a particularly important feature.

To achieve that extra buzz of excitement in your paintings it is essential to take a bold approach at times. We all find ourselves trapped on that plateau, unable to advance our work to a higher plane, and this is usually caused by being too timid to experiment. Even when we are producing competent paintings, we should be keen to take advantage of any opportunity to enhance them. Karen's bold treatment exploits the medium to its full. She achieves this at times by throwing caution to the winds, at the same time maintaining an air of complete equanimity, where many artists would be in an advanced state of super-charged panic! Enjoy the excitement – and the panic! It will push your work that little bit further up the rungs of success. Of course, such an approach is not without an inherent degree of risk, but you have much to gain and the results can be extremely rewarding.

With landscapes we can sometimes get away with muddy colour mixtures – in ploughed fields, for example, or perhaps that murky riverbank. In flower painting, however, simply mixing dull, lifeless greys for the shadows is not good enough – the shadow areas need to be vibrant, transparent and shimmering with life. The sense of light and shadow in Karen's paintings makes her landscape and flower compositions positively glow, and her creative use of colour is a lesson to us all. Her flowers are so alive that they seem to dance on the page, and surely she has made watercolour *the* medium for expressing the beauty of the landscape and the freshness of flowers. It is heartening to see how she delicately describes the dark negative forms to outline a feature caught in the light – and all done with such economy of effort. This is not the easy option, but it deliciously keeps alive traditional watercolour techniques that are sometimes stifled in a morass of thickly-laid masking fluid.

This book is about watercolour painting as it should be: wonderfully fluid washes with glowing colour mixtures, so mouthwatering that you will not be able to contain your desire to get out your paints and try out Karen's methods. She is a very natural teacher with the rare talent of being an adventurous and inspired artist, yet imbued with the compassion and sincerity so vital for anyone teaching such a complex medium.

All those who are familiar with Karen's teachings, whether from one of her popular courses or through watching her videos, will be delighted that she has now taken to print and produced this long-overdue book.

David Bellamy

Introduction

Colour is my reason for painting. Seeing colour in the landscape, on a wet road, in leaves, stones and trees is an endless source of excitement. Light reveals colour, and colour reveals form.

I have painted for as long as I can remember, initially on other people's wallpaper and with anything to hand, until the adults in my world gave me paper and crayons. The journey of exploring shapes and colours had begun.

This urge to make marks has always been one of man's strongest instincts. Once the struggle to survive had abated he made marks on his walls, his weapons and his household tools. The history of art is a history of man's thinking, reflecting his state and beliefs. So much is revealed in his paintings and artefacts – where, when and how the item was created, what influences were prevalent and what religious creeds were held. The social history, the exchange of ideas which reveal contacts, journeys, trade and patronage, all make a fascinating study. The history of art does not reveal a steady growth of skill. On the contrary, the skill has always been there, but the motivation has changed and is constantly changing.

The need to paint and create is strong in man. More and more people today are turning to painting, with sentiments such as: 'It's something I have always wanted to do', 'I do envy you, I wish I could paint', and 'It must be so relaxing'. The latter remark is enough to make any artist see red. Painting is *not* relaxing, although it is indeed absorbing and, as such, an effective counter-irritant, pushing any other problems away for a time. Painting involves making decision after decision; this requires a great deal of concentration and leaves one feeling drained. Few artists paint in an inspirational fit, but with thought and feeling.

For me, as for many of you, painting fulfils a need and a hunger for living life to the full. It sharpens the awareness of one's surroundings, and there are many joys given and noticed each day. Attempting to put down on paper or canvas something we have seen or experienced is daunting, both for the skilled and the less accomplished artist. The dream is never quite achieved, but during the painting you are co-creator for a while and the dream seems possible. This time it *will* be a masterpiece. It seldom is, but each attempt made with sincerity will yield something of what you saw and experienced, and later will revive the memory, as well as touching a chord with those who see your painting.

There are different triggers to a painter. These might be figures, action or movement; architectural subjects, portraits or still life; or the many stimuli acting upon the abstract painter. For me the stimulus is light revealing colour and colour revealing form. Be it in distant hills, dales, still or running water, muddy ditches, flowers or weeds, colour is to be seen out of doors, in the open, under the changing skies. All painting consists of colour and shapes, whether they are in the abstract or representational, realistic or impressionistic. As Cézanne said, 'If you have colour you have form.'

1

Materials and equipment for outdoor painting

Each painter evolves his or her own preferences in the way of equipment: a favourite easel, bag and stool, as well as pencils, brushes, paints and especially the palette. Students often become confused by the conflicting advice of tutors, each recommending different colours and equipment, with the result that the only people who benefit are the stockists.

At the risk of worsening the situation, the following is a list of the equipment that I would recommend for outdoor work.

- An easel and carrier
- A stool with a back rest
- A backpack
- Your chosen paper
- A drawing-board (I use a cheap canvas board as a drawing-board for travelling, which is much lighter)
- A leakproof bottle for water
- A pot for putting water in
- A brimmed hat
- A large dustbin bag
- A paintbox
- An additional palette for blending colours (a plastic picnic plate is ideal)
- A selection of pencils, charcoal sticks, pens and brushes

When travelling really light I dispense with the easel and stool and sit on the dustbin bag, which can be padded with either bubble-wrap or a sweater. If it is cold you can put both feet into it. A spare bag to put your equipment on also saves losing a tube top, eraser or brush in long grass. If it rains you can put your work inside it and at the end of a painting holiday bring your laundry home in it – an invaluable piece of equipment. The backpack is for putting your materials into, leaving your hands free for carrying the rest of the equipment.

Pencils

For drawing prior to using watercolour I prefer a soft pencil: 4B, 5B or even 6B. I use the pencil very lightly and keep drawing to a minimum. With a soft pencil the movement across the paper can be light and free, with the pencil held loosely. If you use a hard pencil you may make a groove in the paper, which the watercolour will pick out. I do like a really good point to my pencil, and keep a Stanley knife handy for the purpose.

Charcoal

Sticks of charcoal (not the pencils) are ideal for making tonal sketches, combined with a putty eraser. The results give a very painterly effect (see overleaf).

Pens

A brown Pilot Hi-tecpoint 5 (0·3 mm) and a small A6 spiral-bound sketchpad are my constant companions in handbag or pocket. This pen is soluble, so with a bit of spit or a wet finger a quick tonal sketch can be made. The advantage of a pen is that, because you cannot rub it out, you have to keep going. The more you sketch the better you get, as the eye becomes quicker at picking out the essentials (see page 11).

Paper

This is a very personal area, as the paper you choose for watercolour depends on and affects your style of painting. For the beginner I would suggest a good

The materials and palette needed for outdoor painting

Stool

Adjustable easel

Easel carrier

Brimmed hat

Paper

Canvas drawing-board

Backpack

Paintbox

Water pot

Dustbin bags

Brush case

Water bottle

Picnic plate

Pans

Paintbox

Cadmium Lemon or Pale

Cobalt Blue

Cadmium Yellow

French Ultramarine

Aureolin

Prussian Blue

Gamboge

Cerulean Blue

Raw Sienna

Yellow Ochre

Light Red

Extras

Raw Umber

Brown Madder

Viridian

Hooker's Green

Vermilion/Cadmium Red

Permanent Rose/Rose Madder (genuine)

Permanent Magenta

1

2

3

4

5

Brushes

1 One-inch flat
2 Squirrel no. 8
3 No. 10
4 No. 24
5 Half-inch flat

Pilot Hi-Tecpoint

A6 sketchpad

140 lb (300 gsm) Bockingford paper. I prefer using at least 140 to 200 lb (300 to 425 gsm) as these heavier weights do not need stretching. Some painters prefer the more absorbent papers, as the colour is more easily controlled, sinking in immediately. I like to make puddles and allow the paint to granulate. I often use a 140 lb (300 gsm) Arches Not, or sometimes Rough, paper. For flower subjects I am happy with Bockingford, a very white paper which results in luminous colours.

Brushes

I like a fat brush with a good point. Sable brushes are nice as they hold plenty of pigment and water, but are not absolutely necessary, as some of the synthetic mixtures are very good. The purely synthetic brushes are also quite adequate.

My current favourite is a no. 24 brush with a perfect point. I also use a no. 10 for more detailed work, a flat one-inch and half-inch brush, and a no. 8 squirrel brush for laying in large wet areas. Thinner brushes hold less pigment and therefore need re-loading more frequently. A fully loaded brush gives you greater control. The pressure can be light to maintain the point, while a heavier pressure will spread the hair.

Paints

I use a watercolour box and pans of paint so that I can get at the whole range at once. Using tubes is fine if you get through them quickly enough, but they do go hard in the tube with time. It is advisable to wipe away tube paint that you have not used up. Never squeeze tube paint into an empty pan, as this will mean wearing out a good brush to get it to yield any colour when it becomes hard. With tubes, use the mixing area of your paintbox and an additional palette for blending the colours. The additional palette can be a plastic picnic plate, which is lighter to carry though not as nice as a ceramic palette. As colour is so important to my work, I clean up the mixing area and change the water quite frequently during a painting session. Scraps of watercolour paper are handy for trying out a colour and testing its wetness.

When buying paint I choose Artist's quality. This is more concentrated, and therefore goes further and gives a more vibrant result. It is worth having the best materials: one needs all the help one can get! For paints such as Permanent Rose or Rose Madder be sure to buy *genuine* pigment. This is expensive, but is essential for achieving some of the clashing colours in nature. Permanent Rose and Rose Madder are similar in colour but are named differently by different

Downs with ploughed field
Charcoal. $15 \times 22\frac{1}{2}$ in $(38 \cdot 5 \times 57$ cm$)$

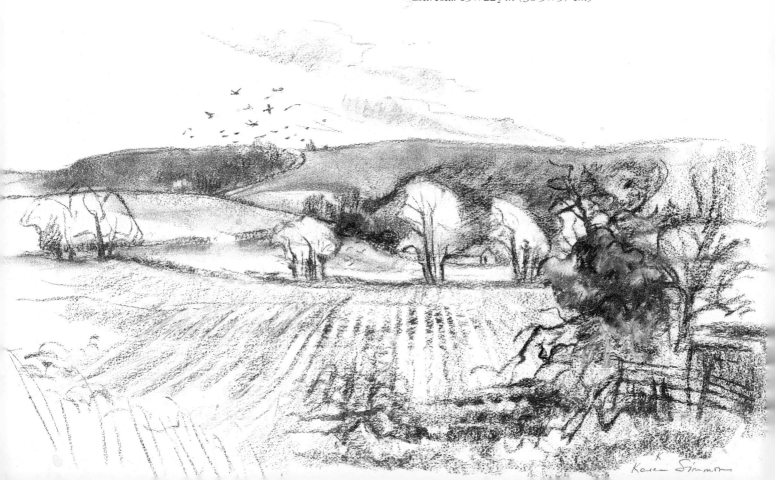

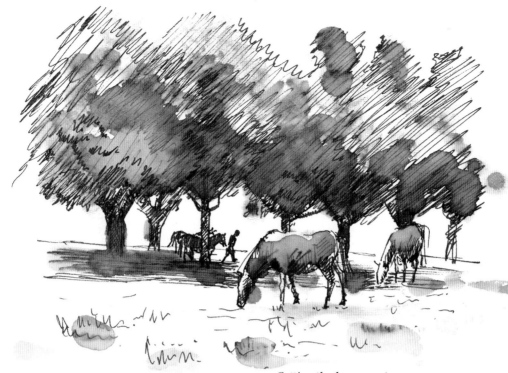

Getting the horses out
Pen and ink. 4× 5½ in (10× 14 cm)

manufacturers. Instead of Lemon Yellow I would suggest that you buy Cadmium Yellow Pale, as Lemon Yellow on its own can be chalky. My own palette is shown below (see also page 9).

- Cadmium Yellow Pale (for Lemon Yellow)
- Cadmium Yellow
- Aureolin
- Gamboge
- Raw Sienna
- Yellow Ochre
- Light Red
- Raw Umber
- Brown Madder
- Vermilion *or* Cadmium Red
- Permanent Rose *or* Rose Madder (genuine)
- Permanent Magenta
- Cobalt Blue
- French Ultramarine
- Prussian Blue
- Cerulean Blue

Some extras:
- Viridian
- Hooker's Green

This is a long list, as some of my work is devoted to flowers, which require colours that are not necessary for the landscape painter. A delightful limited palette for painting landscapes could be Yellow Ochre, Light Red and French Ultramarine, but you could not paint

flowers with that limitation. You will notice that the main list has no greens, as I like to make these myself (see pages 15–18). When travelling to the Mediterranean or the Far East, however, both Hooker's Green and Viridian can be useful.

Chimneypots, Bruges
Pen and ink. 5× 4½ in (13× 11·5 cm)

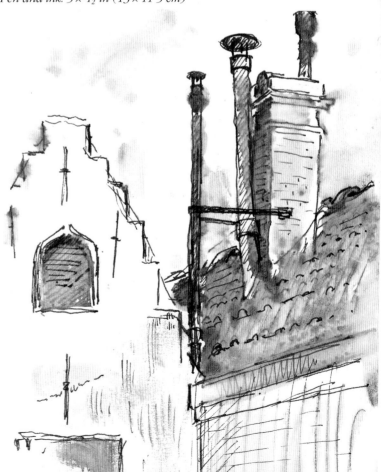

The importance of colour

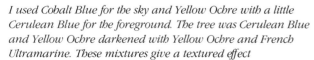

I used Cobalt Blue for the sky and Yellow Ochre with a little Cerulean Blue for the foreground. The tree was Cerulean Blue and Yellow Ochre darkened with Yellow Ochre and French Ultramarine. These mixtures give a textured effect

Here I used a combination of violet and Yellow Ochre throughout, with a touch of Light Red added to the bushes. I made the darks with Raw Umber

The behaviour of the different colours in water is part of the knowledge you will acquire with experience. Part of the fascination of watercolour painting lies in watching the pigment spread in the water, moving with the natural growth movement of nature. Different pigments move at different rates. Allowing the watercolour to do its own thing can often give you the effect you need without interfering with a busy brush. I sometimes use Yellow Ochre in preference to Raw

Sienna because of its behaviour with other colours in water. It separates, so that mixing it with, say, French Ultramarine will cause granulation, giving you a foliage texture without even trying. Another quarrelsome colour is Cerulean Blue, which will also separate from the colour with which you mix it, giving a pointillism effect that can be amazingly vibrant. Try mixing Cerulean Blue with Permanent Rose and you will get the most exciting violet.

Pansy painted in Cerulean Blue and Permanent Rose, with Prussian Blue and Permanent Rose for the darker purple

First I wetted the twig, then dropped in Raw Umber, Cerulean Blue, touches of Permanent Rose and Light Red

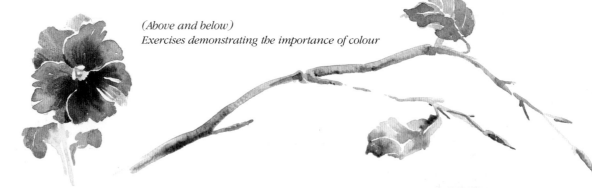

(Above and below)
Exercises demonstrating the importance of colour

Loaded brush of French Ultramarine and Permanent Rose

Paper wetted and then Permanent Rose and Cerulean Blue added

Loaded brush of Raw Umber and Light Red

Paper wetted and then Raw Umber and Light Red added

Paper wetted and then French Ultramarine with a little Raw Umber added, followed by Yellow Ochre which aggressively pushes the first pigment back

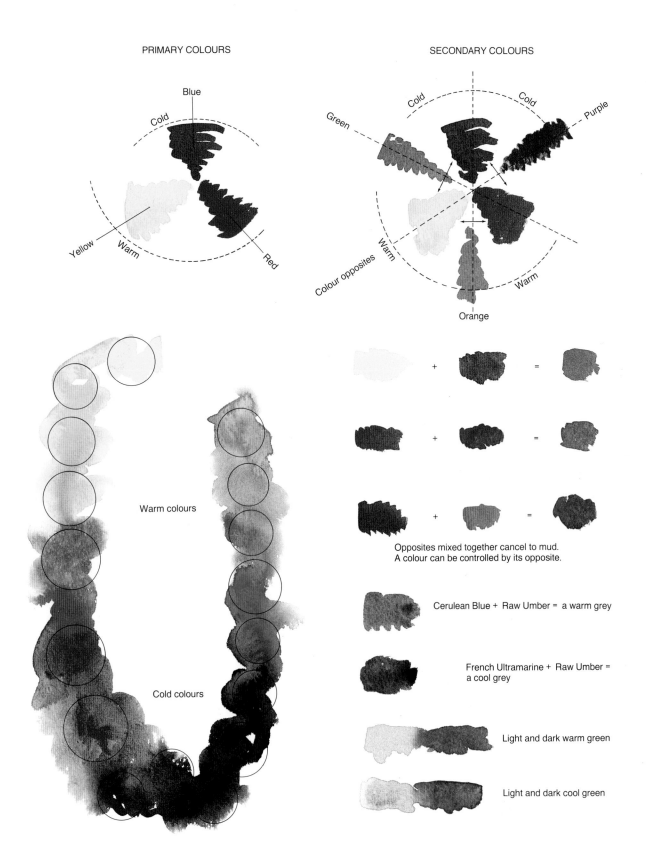

PRIMARY COLOURS

Blue

Cold

Yellow

Warm

Red

SECONDARY COLOURS

Cold

Cold

Green

Purple

Warm

Colour opposites

Warm

Orange

Warm colours

Cold colours

+ =

+ =

+ =

Opposites mixed together cancel to mud.
A colour can be controlled by its opposite.

Cerulean Blue + Raw Umber = a warm grey

French Ultramarine + Raw Umber =
a cool grey

Light and dark warm green

Light and dark cool green

13

Cerulean Blue mixed with Cadmium Yellow gives a bright salad or primrose-leaf green, as well as texture. Cerulean Blue combined with Raw Umber produces a lovely warm grey. Try putting Cerulean Blue and Yellow Ochre together: they will have nothing to do with each other and therefore make a marvellously textured effect due to the way they behave in water. To explore this further, draw several squares, paint some with a loaded brush and some water first, and drop the colour in. The results will be very varied.

Warm and cold colours

How are these recognized? The clue is the presence or absence of yellow. Warm colours contain yellow, and cold colours have no yellow. Reds can be both warm (e.g., Vermilion, Orange, Light Red, and so on) or cold (e.g., Permanent Rose and Magenta), but put Magenta next to a blue and it will look warm. In *Poppies on the seashore*, the use of different reds to describe the

different angles brings in clashing reds and adds vibrancy.

Greens can also be either warm or cold. French Ultramarine with only a tiny amount of Cadmium Yellow will make a cool green. A little French Ultramarine with a lot of Cadmium Yellow will make a warm green. Greys can also be either warm brown-greys, or cool blue-greys. Using more or less water, it is possible to mix light and dark warm colours and light and dark cool colours. With this approach the landscape can be sculpted with colour, while the form of a flower, however fragile, can be revealed by colour.

White

White is the most powerful part of a watercolour painting, and should be reserved for where it is needed most. Too many whites in a painting can look busy. For white areas, the paper is left unpainted: too much texture put into a white area or white flower will

Poppies on the seashore
16 × 19¾ in (40·5 × 50 cm)

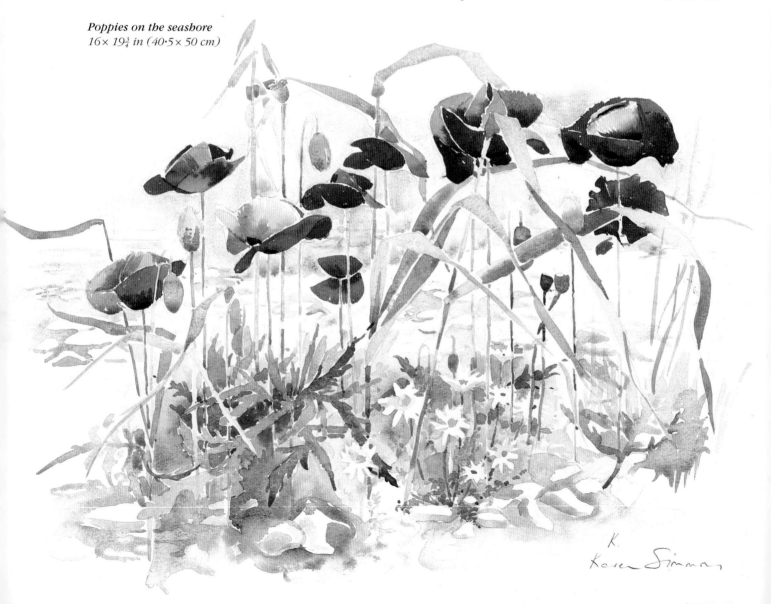

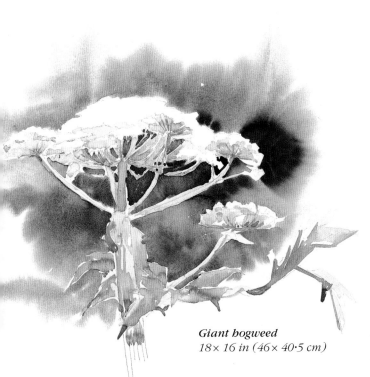

Giant hogweed
18× 16 in (46× 40·5 cm)

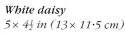

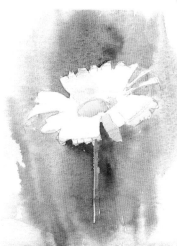

Small yellow rose
*This painting illustrates the use
of white with yellow, and yellow
with white. 6× 6 in (15× 15 cm)*

White daisy
5× 4½ in (13× 11·5 cm)

diminish the white, weakening its carrying power. The impact of white is the greater truth, so don't trample in the snow. White will look brighter with a touch of yellow nearby; yellow will look a lot brighter with white nearby. This is true of watercolour, and is also effective in pastel.

Darks

A dark accent in a painting also needs care. It should be reserved for the foreground area only, while darks in the distance or middle distance need to be muted to suggest space. If the dark describes a hole, such as an open barn door, a window or a cave, you should introduce Cadmium Red into the dark (e.g., French Ultramarine, Raw Umber and Cadmium Red, or Prussian Blue and Cadmium Red) to create a red dark. A red dark will be blacker than black should you need it, and is also more recessive than a blue dark. It's true – try it! To darken a colour use the colour's own opposite and less water. For example, to darken a red, use a little green, and to darken a green, a little red.

Greens

Greens can be a problem area. It may be wiser to aim for the *illusion* of green, without filling your painting with a bright green – however truthful. An over-green painting is hard to live with.

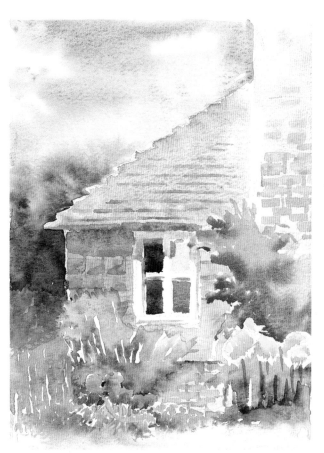

Cottage window
I used red darks to describe the window and part of the background foliage in this small study. 9× 6½ in (23× 16·5 cm)

15

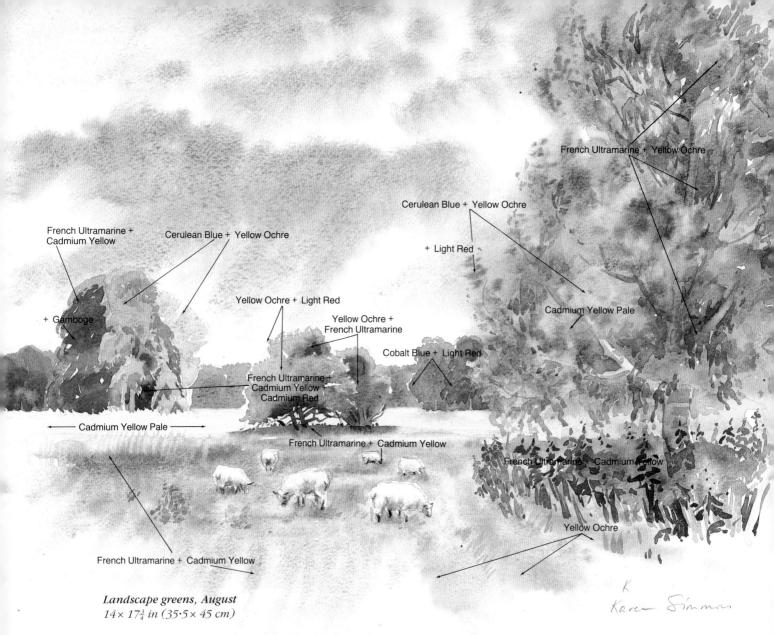

French Ultramarine + Yellow Ochre

Cerulean Blue + Yellow Ochre

+ Light Red

Cadmium Yellow Pale

French Ultramarine +
Cadmium Yellow

Cerulean Blue + Yellow Ochre

Yellow Ochre + Light Red

+ Gamboge

Yellow Ochre +
French Ultramarine

Cobalt Blue + Light Red

French Ultramarine +
Cadmium Yellow +
Cadmium Red

Cadmium Yellow Pale

French Ultramarine + Cadmium Yellow

French Ultramarine + Cadmium Yellow

French Ultramarine + Cadmium Yellow

Yellow Ochre

Landscape greens, August
14 × 17¾ in (35·5 × 45 cm)

Thinking in terms of warm and cold greens will help enormously. In the northern hemisphere the midday light is cold. Flat or nearly flat areas will be sky-related, reflecting a cool colour. A leaf at a flat angle will therefore have a blue note, and at a vertical angle its own true colour, and, when the light comes through it, the leaf will be a warm yellow-green. Looking across a landscape in the middle of the day, the swell of the fields and hills and the domes of trees will be cool, while in the foreground the shadow areas will be warm. With the warmer light at the beginning and end of the day the reverse will be observed and the shadows cool.

When in doubt about the subtle differences of green in a landscape, bend over and look at the subject upside-down: the blood will rush to your head, enhancing colour perception. Seeing the subject from a different angle also makes one more observant.

Everyone expects artists to behave strangely, so these antics will only provide amusement to any onlooker.

The following are some useful green recipes. For a light, cold green, use French Ultramarine with just a litle Cadmium Yellow, well diluted, or Cerulean Blue with a very little Cadmium Lemon, well diluted. The less yellow you use, the colder the green will be.

For a dark, cold green, mix French Ultramarine with very little Cadmium Yellow and less water.

For a light, warm green, use Cadmium Yellow with a small amount of French Ultramarine well diluted with water, or Cadmium Yellow with a little Cerulean Blue. You can also combine Yellow Ochre with Cerulean Blue: this mixture will granulate heavily, giving a textured effect.

A very dark green can be achieved with French Ultramarine, Cadmium Yellow and just a little Cadmium Red, with very little water. The addition of red

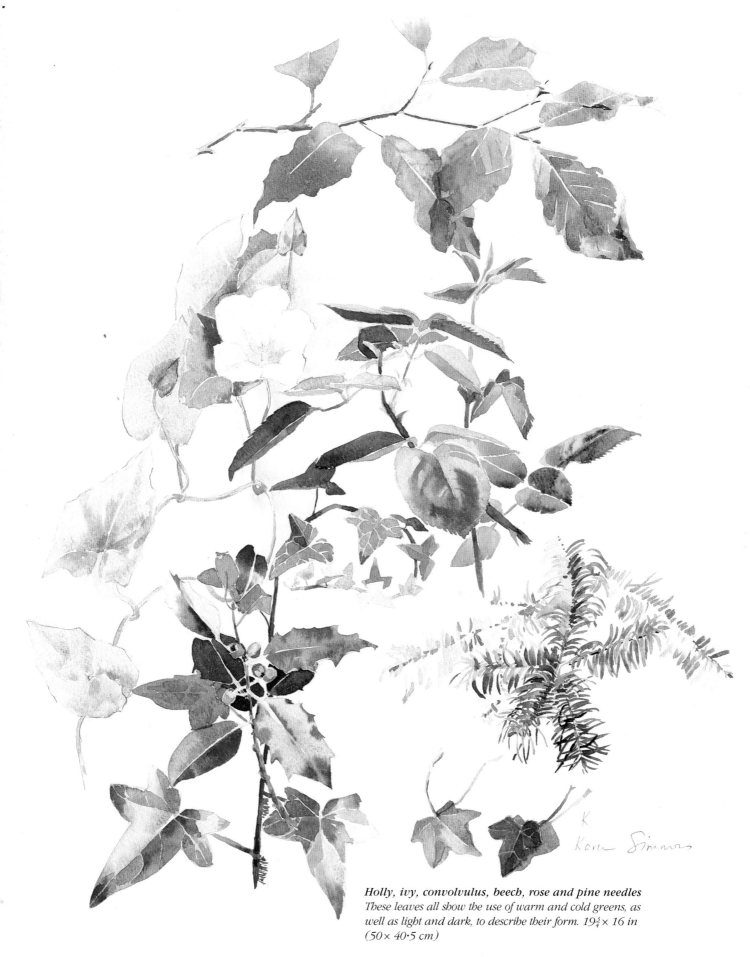

Holly, ivy, convolvulus, beech, rose and pine needles
These leaves all show the use of warm and cold greens, as well as light and dark, to describe their form. $19\frac{3}{4} \times 16$ in (50 × 40·5 cm)

17

will darken the green, and, when dry, it will remain a rich, dark green. Too much red will make a very muddy colour.

French Ultramarine with Yellow Ochre will granulate well and give a very sombre green, well-suited to late summer foliage in northern Europe.

Raw Umber with Cadmium Lemon Yellow will make a lively lime green, or, with only a little yellow and less water, an olive green.

Should you need a really bright green, Prussian Blue mixed with either Cadmium Yellow Pale or Cadmium Yellow will give you a very lively green. Mixing Prussian Blue with Cadmium Yellow Deep (which is nearly orange and the opposite of blue) will give you a muddy green.

For a green lawn I might use a wash of Cadmium Lemon and, while wet, shadow it with Cobalt Blue, letting the two fuse together to give the illusion of green. Again, the colours move in the water, producing a grass-like effect.

Greys

Greys can be a lovely ingredient in a painting. There are cool blue- or pink-greys, greeny-greys, and warm and brown-greys. A useful soft grey can be made with Cobalt Blue and Light Red. Vary the combination and you will get an amazing range of greys. Cerulean Blue and Raw Umber, or French Ultramarine and Raw Umber, will give you both a warm and a cool grey, and there are many more possibilities.

Shadow colours

Shadows consist of colour as well as tone, and the quality of the colour in shadows can really make a picture glow. The colour of a shadow depends on the light, the surface it is on and the surroundings. You may get an upwash of light bouncing off a sunlit wall or path, for example – a ricochet of colour into an otherwise shadowed area.

The shadow colours used for flowers can make or break the painting. The shadows for yellow flowers such as the yellow rose or daffodils can be particularly full of hazards. This colour's opposite (violet) makes an ideal shadow colour, dissolving into a grey or bronze. I make violet with Cerulean Blue and Permanent Rose, and find this successful for shadow colours on yellow flowers. It is possible with this combination

to make a blue-violet or a red-violet. Overlaying the yellow with a blue-violet will give you greeny-grey to grey; with a red-violet the overlay will have a bronze hue. I also use Cobalt Blue with Permanent Rose in a similar manner. Sometimes I add this while the yellow is still wet, as in *Yellow rose*, shown here. At other times I will overlay it when the first layer of yellow is dry.

For a pink flower a warm red will both shadow and clash, adding vibrancy. This will be the right shadow colour where a blue-red would kill the flower.

Yellow rose
18 × 15¾ in (46 × 40 cm)
This painting is demonstrated in detail in my video 'Flower Painting' (see page 4)

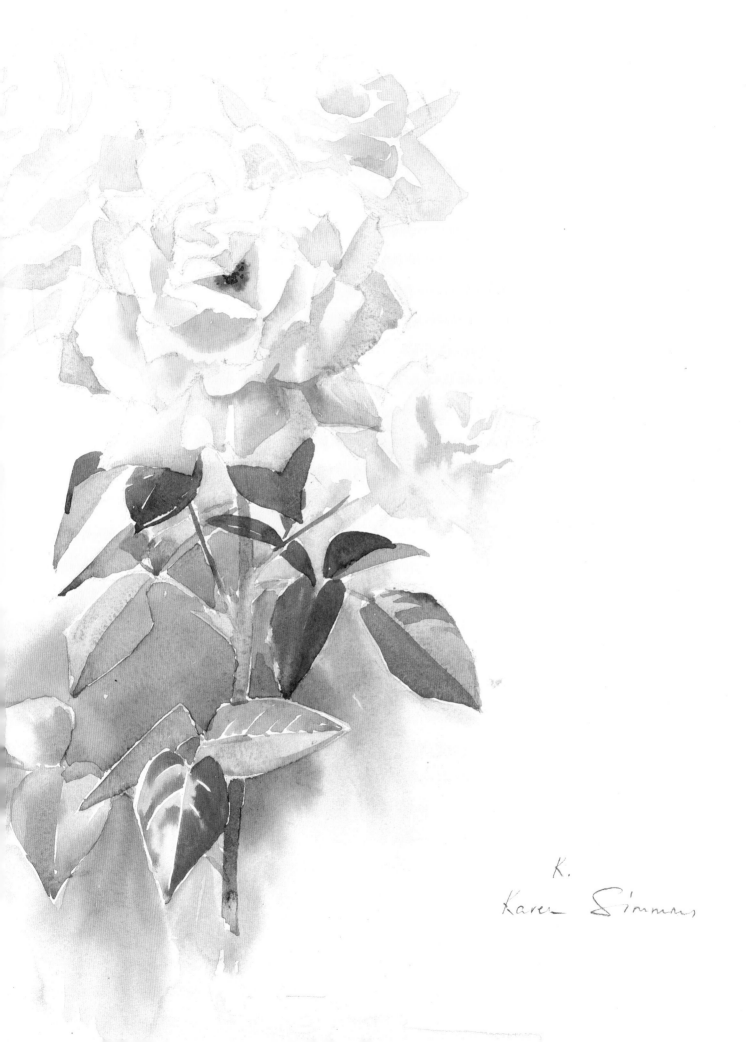

K.

Karen Simmons

3

Drawing

Although this book is about colour – indeed about colour revealing form in natural light – the foundation to any painting is drawing. Whether you make pencil marks or not, one is drawing mentally; in fact the better you can draw on paper the better you will draw in your head, leaving the pencil marks out – rather like mental arithmetic. Most of us, however, do feel happier with some foundation drawing.

Plotting a drawing

This involves the early stages of planning a composition: the relevant heights, widths, angles and space shapes. Making a diagram plan will soon show how the various ingredients and shapes can be composed. At this stage, the layout of the composition can be checked and if necessary altered without having to remove detailed drawing.

Putting trees, flowers and leaves into diagram boxes can be enormously helpful in keeping the proportion of the subject and its perspective on the right course, before invading the box with the gaps and spaces required. Only when the plotting is right, the composition pleasing, and what you wish to have in focus well-positioned, should you move into paint. I have heard so many times, 'Oh, that will come right when I paint.' If you leave it until then you will have a fight on

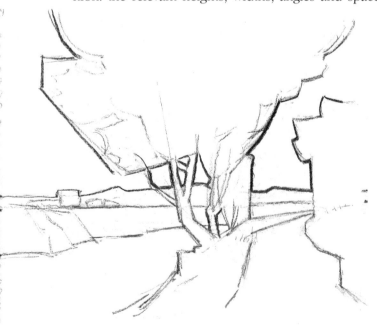

Pevensey Marshes
Plotting drawing showing sky shapes. $16\frac{1}{2} \times 20$ in (42×51 cm)

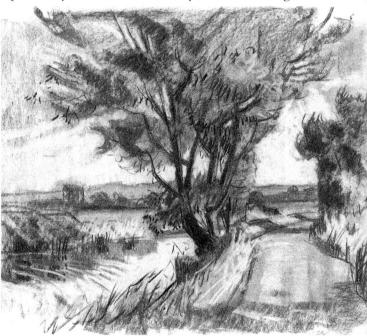

Pevensey Marshes
Tonal drawing. $16\frac{1}{2} \times 20$ in (42×51 cm)

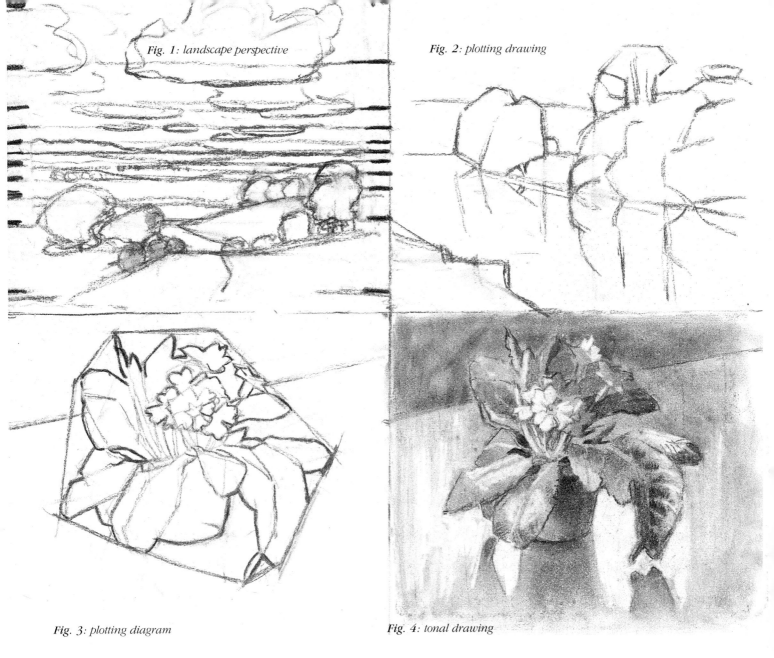

Fig. 1: *landscape perspective*

Fig. 2: *plotting drawing*

Fig. 3: *plotting diagram*

Fig. 4: *tonal drawing*

your hands. The advantage of approaching the work in this way is that it helps to identify what it is you want to paint: the *why*, the *story* of what has switched you on. As George Perkins Marsh, the author of *Man in Nature* (1864) said: 'Sight is a faculty, seeing is an art'; or as Henry David Thoreau put it: 'The question is not what you look at but what you see.'

Plotting a drawing enables you to see what you need to keep in a composition and what is irrelevant, and whether your story would be best illustrated in a vertical or horizontal format. Such decisions are all part of the digestive process and, despite the length in the telling, need only take a few minutes of your precious time.

Tonal sketching

Before even starting on your awaiting masterpiece, a quick tonal sketch is essential. Having a tonal understanding of your subject will give an extra dimension to your painting. Virtually all artists carry out several tonal drawings before beginning. The less experienced painter often gets impatient, doesn't see the point, or, having tried it, makes the valid point that all the zest has gone into the sketch with the subsequent painting losing out. Yet tonal sketching need not take long nor use too much precious zest.

Tone is the relevant lights and darks in the painting, the key word being *relevant*. It can range from the dainty but true tonal quality of a Beatrix Potter to the stronger, simpler, equally true quality of a Seurat.

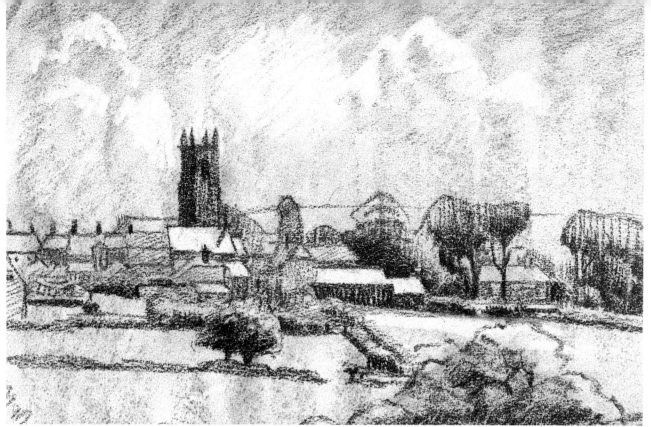

Stoke Climsland
Tonal sketch in charcoal. 9 × 13¾ in (23 × 35 cm)

When approaching any subject, identify the lightest area, the darkest area and where several shapes merge into a shared tone. For example, is the road or path lighter than the field? Is the roof lighter than the trees around it? Is the gate or tree lighter or darker than what lies behind? How does the dark tree in the middle distance compare with the foreground dark? Contrasts of tone fade and merge with distance. Half-closing your eyes or looking through tinted perspex or cellophane helps in seeing the tones, as you lose some of the detail. A good tonal sketch will provide you with reference material to take back to your studio, should time be short. Many painters do all their work in this manner, removing themselves from the temptation of putting all the goodies in. Sometimes I also work like this, but, being passionate about seeing the natural light and colour on the subject, I do most of my work in the open, having first carried out the tonal sketch.

(Left) **Sussex lane**
Tonal drawing in charcoal.
16 × 19¾ in (40·5 × 50 cm)

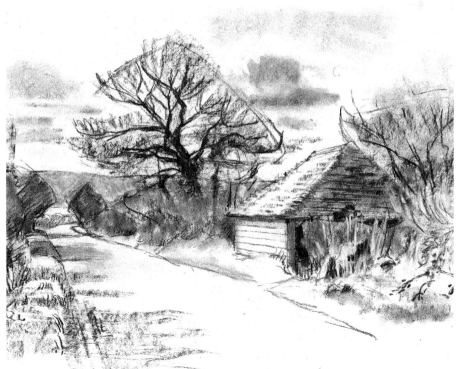

(Opposite) **Stream with footbridge**
Charcoal. 22 × 16½ in (56 × 42 cm)

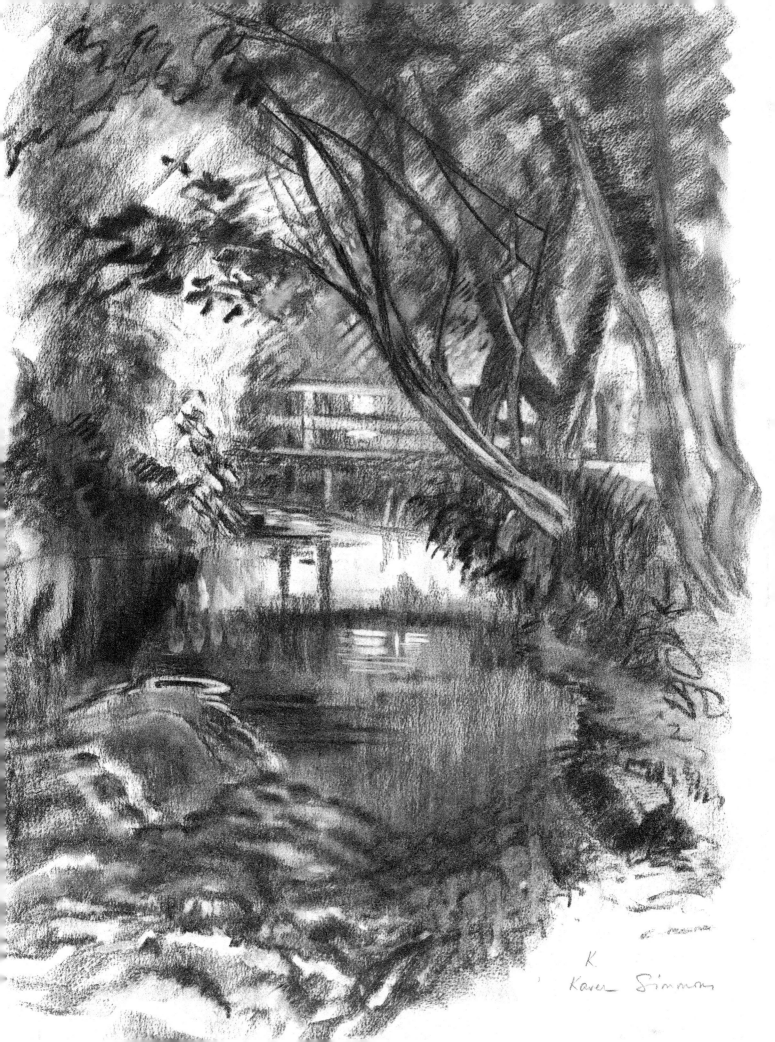

Karen Simmons

4

Colour in landscapes

Colour is constantly changing from dawn to dusk; it changes with the weather and with the seasons. One could paint a particular view over and over again, each time getting a different result, as Monet did with his haystacks and Rouen Cathedral.

If you capture the colour and tone accurately, your painting will describe the temperature, even the humidity of that moment in time. How can this be achieved? By careful observation of each colour and tone and how it relates to what lies next to it.

Selecting your composition

Before reaching the painting stage, you may discover that you have problems finding a subject and then selecting your composition. It is all so bewildering; landscapes do not come in ready-made compositions. *You* have to choose.

Something about a given view has made you pause. Why? Try to analyse what it is that has caught your eye. Is it a gap, or a track between some trees? A farm snuggling into a valley? The rhythm of stone walls? The colour of shadows on buildings? What is your story?

With this in mind, what is relevant to your story can be kept, and the rest discarded or made to play a supporting role.

Planning your composition

Start by making some very simple sketches, placing your focal point to advantage and finding out whether the composition would work better in a vertical or horizontal format. Take note of where any strong verticals may come and where the horizontal lines might lie (see the illustration on page 20 [left]). The quick doodles on a page help to digest the subject, clarify your motives and tell your story better.

On your chosen sketch, roughly hatch in the tones. A quick way of doing this is to shade off all areas except those that are white or light. These could be a roof, water, a wet road and sometimes, but not always, the sky. Then hatch in the darkest accents: these are usually in the foreground. Hatch in the medium tones next, which you may find can be shared across several shapes. You can now visualize your future painting. (See also *Stoke Climsland* on page 22 [top].)

This process need not take more than ten minutes or so. There is another hazard, however. Does your sketch lose something when it is translated to a bigger piece of paper? The chances are that in stretching to fill your bigger space you have widened up the gaps and lost some of the drama and excitement. The answer is to plot your composition, watching out particularly for the sky shapes. This is a very useful exercise, which helps to keep the proportions in check. Alternatively, you can make a grid and use it to help keep the proportions the same while working on a bigger scale. One more thing – you do not have to fill the paper!

I have found this whole approach helpful, because in watercolour there should be more 'thinking' time and less 'doing' time. One needs to think out all the tactics first, before launching into work.

Part of the thinking time can be devoted to observing the warm and cold colours in the subject. This is especially useful in the British Isles, where one is assaulted by greens in the landscape. Seeing the greens and greys in terms of warm (containing yellow) and cold (the absence of yellow) can help to sculpt the shapes of trees, hills and meadows.

(Above) **Sussex Downs**
*An exercise in warm and cold colours. 12 × 15¾ in
(30·5 × 40 cm)*

(Below) **The cottage garden**
*A demonstration of the use of warm and cold greens.
16 × 19¾ in (40·5 × 50 cm)*

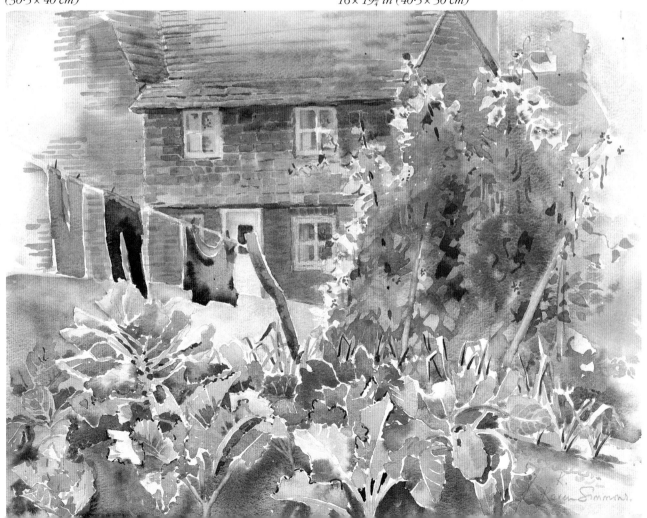

An easy exercise which can produce a lovely result is to paint a landscape or any subject in semi-monochrome using warm and cold greys. Use Raw Umber (warm), Raw Umber with French Ultramarine (cool) to French Ultramarine on its own (cold).

The cottage garden *(see previous page)*

This painting is a close-up example of using warm and cold greens for the cabbage leaves. The colour describes exactly which way the leaves are facing: some parts towards the sky (cold), and some with the light coming through them (very warm).

Spring sunshine

It is odd that one sometimes catches sight of a good composition in one's wing mirror. It happened to me as I was driving along a nearby country lane – there it was, caught in the mirror.

I drew off to one side and walked back. The bright white slats with the vivid lime green of the little tree across them, the roof warmed by the spring sunshine and the magnificent oak to complete it, certainly proved to be a good subject. I was further seduced by a flint building covered in ivy that flanked the right-hand side of the road. I tried out possible compositions, framing them with my fingers, but finally decided to abandon the flint building and keep to the wing-mirror composition!

I happened to have paper and charcoal with me, and sat in the tailgate of my car to sketch this scene on A2-size, 70 lb (150 gsm) watercolour paper. I find this paper too thin for watercolour, but it has a bit of tooth and is therefore well-suited to charcoal.

The composition of the charcoal sketch is better than the finished picture (see page 29). By altering the

Spring sunshine
Charcoal. $16\frac{1}{2} \times 23$ in ($42 \times 58 \cdot 5$ cm)

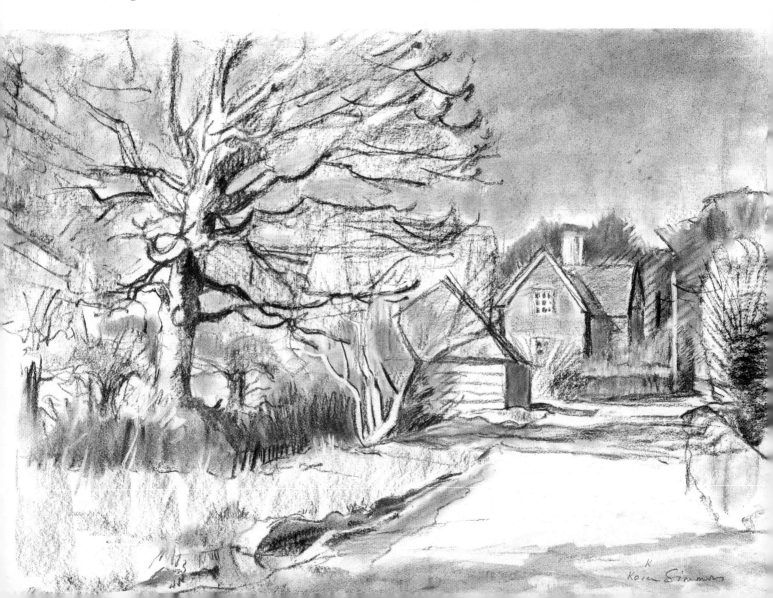

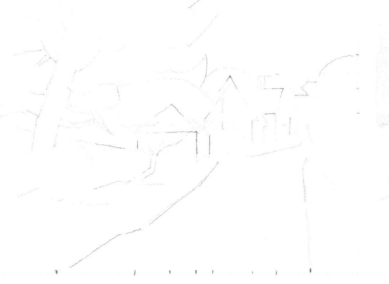

Stage 1

Stage 2

proportion of the paper in the painting, what had been an offset white shed became central. I hope the lane leading off to the right-hand side compensates for this, and that I might be forgiven!

The charcoal sketch shows that for the big oak I took care with the drawing of the tree and branches, really observing the major shapes. I noted the sky shape and shaded it in. I then drew in the house and shed, noting the gap shape between the house and the right-hand hedge. The tree in front of the white shed was also carefully observed.

I then drew in the angle and tone of the hedge on the left, the grass verge and the lane. Smearing the charcoal and then lifting it off for the lights, before coming back with the charcoal to deepen where necessary does give a very good idea of what the finished painting could look like. I had a red Conté stick with me, and used this to tint in the warm red areas.

Most painters can memorize colour, or may make written notes on the sketch. What are more difficult to remember are the relevant tones. Is the sky lighter or darker than the road? Is the hedge lighter or darker than the verge? The shadows and the strengths of darks between the distance and foreground also need to be noted. It will then be possible to work from your charcoal tonal drawing back in the studio if necessary.

I painted *Spring sunshine* on a sheet of Arches 140 lb (300 gsm) *grain fin* paper.

Stage 1

I started the work by making the plotting drawing. This simple drawing shows the sort of planning I do. It shows the sky and road shape, and where the hedge and grass-verge line come in relation to the edge of the picture. You will see some dots along the edges. This sort of planning gets the composition placed, with the minimum of pencil drawing.

Stage 2

In this painting the soft spring sunshine gave every-thing a warm glow, making a common-denominator colour of Light Red.

For this first wash I wetted the whole paper except the white-slat wall. While the shine on the wet paper still remained, I flooded in some dilute Light Red, with a touch of Yellow Ochre towards the right-hand side.

Stage 3

Before the paper had dried, I washed in some Cerulean Blue combined with Cobalt Blue at the top, letting it drain down over the Light Red wash.

The foundation of Light Red has kept the distant blues soft and recessive. I painted the tree trunk and some branches with Cadmium Yellow Pale and Yellow

Stage 3

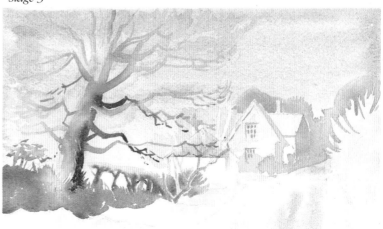

Ochre. I deliberately added the branches while the sky was still damp, knowing that they would shoulder the blue away. This gave an out-of-focus effect to some of the branches, adding depth to the mass of twigs.

The paper was now dry, and I added more branches and twigs by putting on some paint and, while this was wet, adding more, letting the pigment travel along the branches to imitate nature. For the bright green in the trunk I used Cadmium Yellow Pale with some Cerulean Blue, then darkened it with a purple made with French Ultramarine and Permanent Rose. This cancelled out in places to look quite brown. I added some Light Red where the low sun lit the branches.

I painted in the shadow marks and windows of the distant house and the trees behind it, using the gentler Cobalt Blue mixed with Permanent Rose and muted with a little Yellow Ochre. The original wash remained for the walls.

I used the deeper colour of the trees on the right to invade and shape the lighter bush.

Stage 4

I added some more Light Red and mauve to the foreground bushes, and, when this in turn had dried, deepened the colour in places to cut out the sapling stems and branches. I had already painted the very light green tree across the white shed, using a mixture of Cadmium Yellow Pale and Cerulean Blue to make a vivid green. I then painted the rich red of the roof, going carefully around the branches. For this colour I used Permanent Rose with Yellow Ochre, and Permanent Rose and French Ultramarine for the shadow.

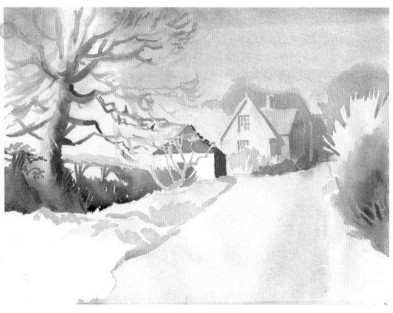

Stage 4

The finished painting

I painted the shadows on the slats with Cobalt Blue. I then took a clean, wet brush along below the line, letting some of the colour bleed out to give a softer effect.

I patterned the grass verge with shadows in the rough grass. Where these were light, I used pure

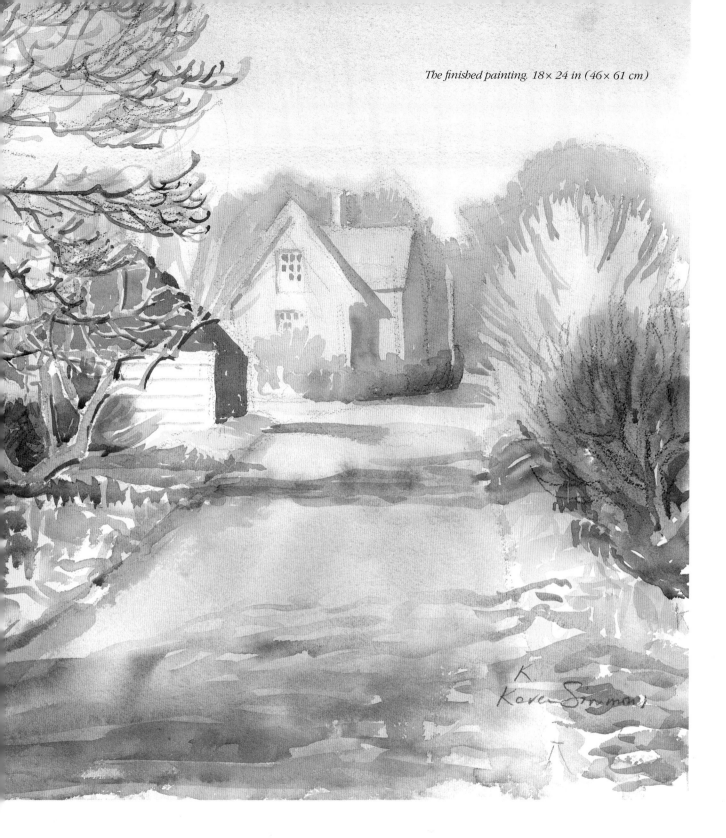

Cadmium Yellow, shadowing with a blue-green French Ultramarine with a touch of yellow. Some of the original wash showed through in places. I painted the foreground grass in shadow vigorously with French Ultramarine and a little Cadmium Yellow. After this, I re-wetted the road and added the mauvy-blue shadows across it while the surface was damp. On the verge, I deepened the shadows in the grass with French Ultramarine and Cadmium Yellow. Lastly, I added a little more detail to the hedge on the left, emphasizing a few unshed beech leaves that echoed the glowing red roof.

The kissing gate

Walking along the edge of a ha-ha on an estate in Nottinghamshire, and gazing at the attractive open landscape, I nearly missed seeing the gate, almost at my feet. Sadly no longer in use, the tangle of weeds and the rusty iron appealed to me.

I returned to it early in the morning of the following day, when it was even more interesting in the low, warm light of the rising sun. The mature weeds of late August, such as the reddish sorrel, dried grasses and drab nettles and brambles, were catching and interrupting the sunshine and casting long, soft shadows.

I painted this picture in two stages as my time was very limited (not always a bad thing!) Luckily for me, the fine weather held and on the following dawn I was able to complete it. A detail is shown on page 32.

I drew the ironwork carefully with an eye for the space shapes to keep me true, especially on the left side of the gate. I used Light Red warmed with a little Yellow Ochre and painted in a few of the uprights and bars, darkening with French Ultramarine and more Light Red. At the very top of the knob, the sheen was catching some of the blue of the sky above, for which I used Cobalt Blue.

Some of the bars were really rosy with the early sun and only needed the Light Red and Yellow Ochre mixture. Where the shadows were strong I still used French Ultramarine and Light Red, but with less water. The pigment travelled in the water in a fair imitation of the rusty surface.

Some of the clear, wet leaves of the nettles and brambles were reflecting the blue of the sky, and I accepted this and used Cobalt Blue again. By contrast, behind these some of the nettles had the sun coming through the leaves, so I used Cadmium Yellow with only a touch of Cerulean Blue to make a very warm, glowing green. The grasses were a mixture of Cadmium Yellow and Yellow Ochre.

The dock or sorrel leaves go a wonderful colour at this time of year, from green and gold to peach and red. I used Cerulean Blue and Cadmium Yellow, with a little Light Red, in various combinations. I put in some of the darker accents with French Ultramarine and a very little Cadmium Yellow.

The next morning I tackled the background. Wetting carefully around the bars and taking the wet brush to all corners, I then washed in some Light Red across the horizon area. I followed this with one or two sweeps of Cerulean Blue, and then a small amount of very dilute Yellow Ochre, coming down the painting

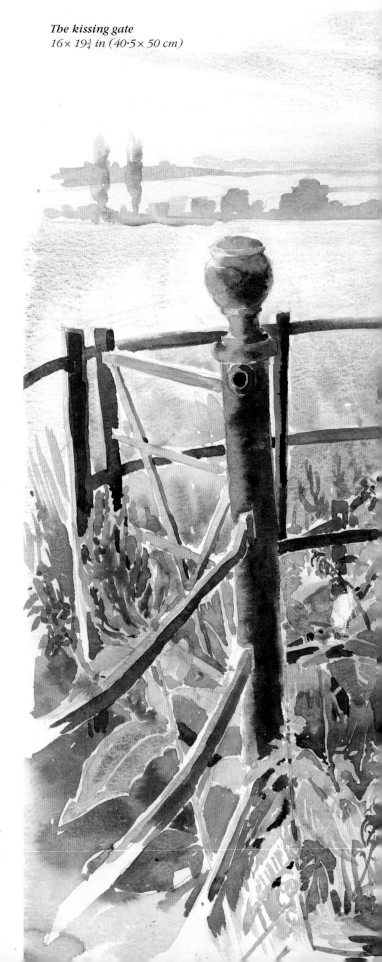

The kissing gate
$16 \times 19\frac{3}{4}$ in $(40 \cdot 5 \times 50$ cm$)$

and deepening the yellow in the foreground. Working fairly fast, I added some Permanent Rose and Light Red for some of the weeds seen through the bars, as well as some more green touches.

With the Yellow Ochre still damp, I added the shadows on the grass from the bars with Cobalt Blue. When this had dried, I painted in one or two forward-leaning nettles.

In the top right-hand corner, I painted some small trees – which were already beginning to turn but were made more rosy by the light – with Light Red, to which I had added just a little Permanent Rose, shadowed with Cerulean Blue. The trees on the horizon were very soft silhouettes of blue and mauvy-blue, and I suggested these with Cobalt Blue and Permanent Rose. I painted the nearer hedge and the trees with Light Red, and added Cobalt Blue to deepen the tone behind the lighter trees. Time had run out again – probably just as well.

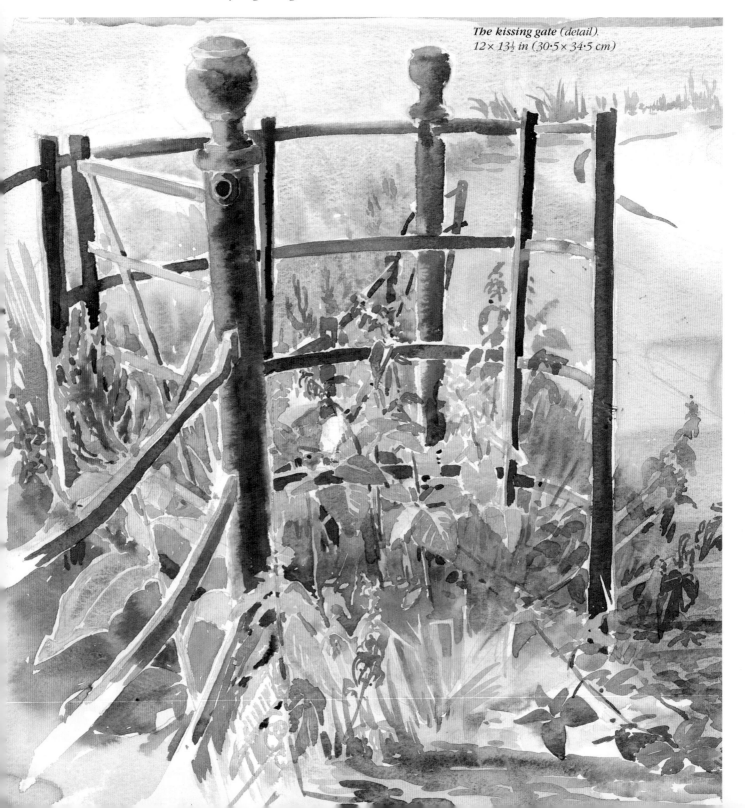

The kissing gate (detail).
12 × 13½ in (30·5 × 34·5 cm)

Prayer flags

I was taken to this beautiful spot in the south-east corner of Austria, known as Styria, by my Austrian brother-in-law, Hans, who showed me the charming little chapel on this knoll of a hill and then left me there to be picked up later. With such a richness of views and subjects around me, I wandered about in near panic, trying to decide which to choose and what to do in the precious time I had available.

I was drawn to these two maize stems standing on their own with the evening light glowing through the leaves, the breeze lifting and fluttering them like Tibetan prayer flags. The atmosphere of the place was indeed conducive to prayer, and the stand of maize enlightened with colour stood like a congregation.

With the chapel behind me I sat on the ground using the faithful dustbin bag and started drawing the two maize stems. I noted where the distant mountain shape came in relation to them with a mark or two for the intervening levels. I painted the two maize stems first, enjoying the light and colour through the leaves which did not stay still for a minute. The stems were a rich red, seen at intervals.

When these two were complete I painted in the sky and background by first wetting around the stems and leaves and away to the edge of the paper, as I do for flower-painting backgrounds. I used Raw Sienna with Permanent Rose for the sky; this mixture gives a lovely transparent coral colour. This colour flowed right down to the foreground edge, becoming the foundation colour for the 'congregation'.

When this was dry, I mixed some Cerulean Blue and Permanent Rose, and some Cobalt Blue and Permanent Rose, and, using this variation, painted the distinctly shaped mountain and distant hills, bringing the colour down and cutting out the tips of the 'congregation'. I deepened the colour in places by adding some French Ultramarine, and some Yellow Ochre for the top of the laden apple tree. I also put in other trees while this stage was still damp. I added a few details to the apple tree to suggest leaves, branches and some rosy apples. They were part of the harvest theme, but had to be kept quiet to favour the sunlit maize.

The colours caught in the 'congregation' were amazing. I added Cadmium Yellow, Cadmium Orange and Cadmium Red in places. I then put in a few cool shadowed leaves and stalks, using French Ultramarine with some of the colours on the mixing palette.

Lastly, I painted the foreground stubble, blond and dry with shadows running up the furrows, with French

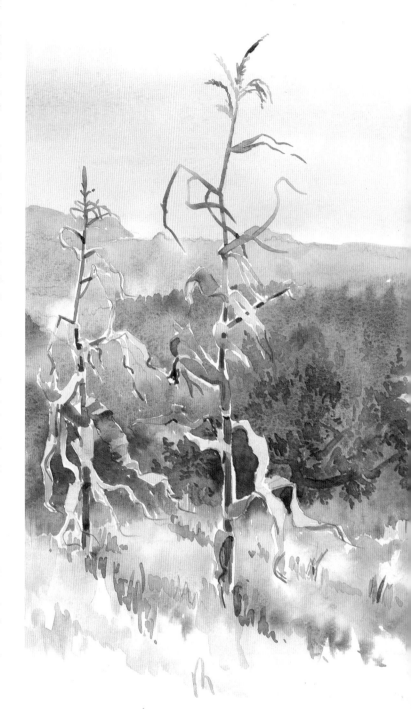

*Detail of **Prayer flags** (the full painting is shown overleaf)*

Ultramarine and a little Permanent Rose over the light ground of Raw Umber, Yellow Ochre and Light Red.

By now the light was fading and my sister Anne had joined me. We stood in silence for a while before heading down the hill and home.

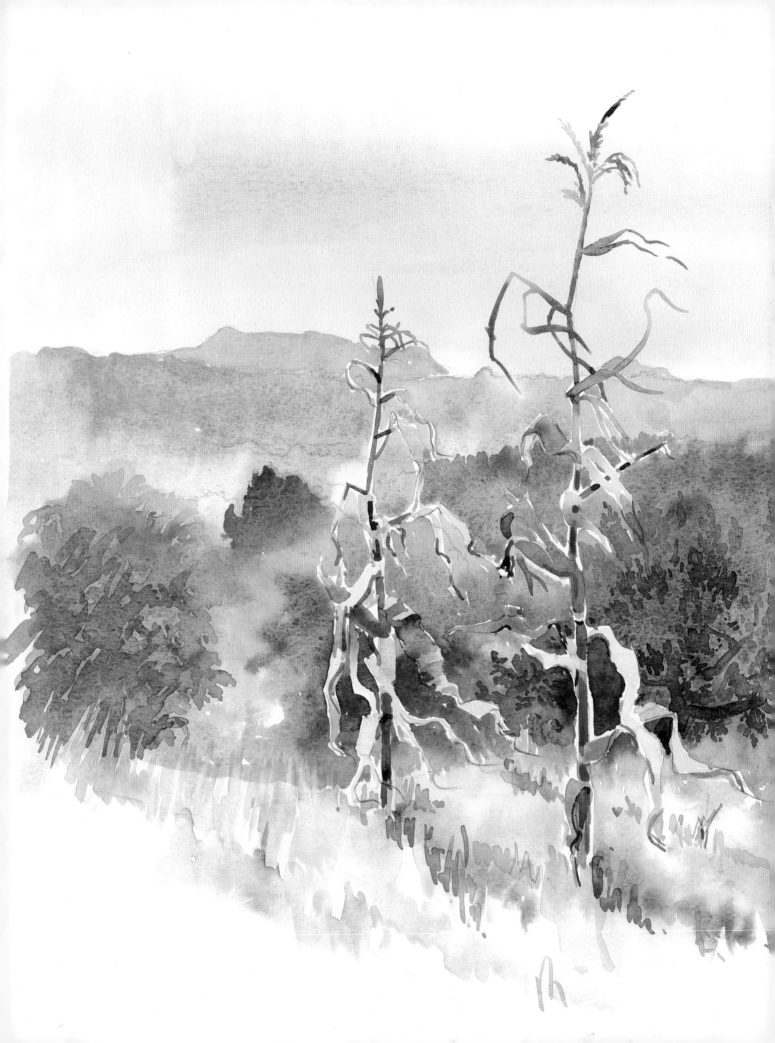

Prayer flags, *so called because the fluttering maize leaves evoked an image of the prayer flags of Tibet.* $16 \times 19\frac{3}{4}$ *in* ($40 \cdot 5 \times 50$ *cm*)

Chapel at Pogonia

The chapel at Pogonia in western Greece is dedicated to the Virgin Mary. It sits, with its separate belltower, on the hillside, with a rocky slope rising steeply behind. Tall cypresses stand around and a huge pine shades and dwarfs the chapel.

I had painted above and behind the chapel before, but this time I painted it from below, across a bleached field. It was the setting and the shadows on the wall that I wanted to capture.

I kept a lot of the foreground dry and white, and washed over the rest of the paper with a very faint tint of Light Red warmed by a little Raw Sienna, with just a little Cerulean Blue coming in from the left-hand side.

I streaked the roof with a wet brush, just allowing a little of the first light wash to show through, and then dropped Light Red, Yellow Ochre and a touch of Light Red with Cobalt Blue into the prepared wet grooves. I ran a deeper purply-red along the front, following the shape of the pantiles. It can be a temptation to paint a roof too dark. The shallower the angle, the more sky-related the roof colours should be.

As shadows are transient, I needed to put them in quickly, and I noticed that the blue shadow varied from a warmer Cerulean Blue to pure Cobalt Blue, with a tiny amount of Permanent Rose.

The rounded arches were lit from below with reflected light; I added a touch of Yellow Ochre here. I put in the dark of the windows with a weaker mixture of French Ultramarine and Raw Umber with a little Cadmium Red, then added a stronger mixture of the colour with a little more of the red and less water. The dark had to represent dark as well as distance, so I took care not to make the windows too stark.

The belltower, mostly in dappled light, came next, and then the huge pine. I used a weak solution of French Ultramarine with a touch of Yellow Ochre to profile the tree, giving it its outer shape. I used French Ultramarine, a little Yellow Ochre and Cadmium Red for a very dark part at the base of the tree. I also dropped in a little warmer green by adding Cadmium Yellow, which travelled uphill. I kept the top part of the pine much lighter than it really was to render it out of focus; this prevented the pine from overpowering the chapel.

I painted the cypresses behind the chapel in a similar way. I also deliberately underplayed the big cypresses to the right.

The bushes of wild sage showed yellow. The young olive trees had their distinctive shape and silver

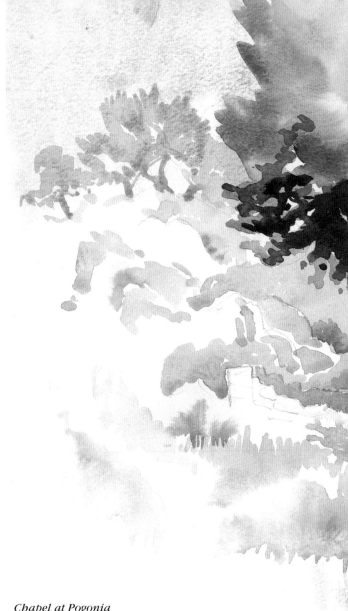

Chapel at Pogonia
$16 \times 19\frac{3}{4}$ *in* ($40 \cdot 5 \times 50$ *cm*)

colouring, and for these I combined Cerulean Blue with Light Red to make a lovely silver-grey.

I used the deeper colour of the field at the top to show up and throw forward the near-white grasses and barley stems. I added just a few dried weeds in the front.

As you can see, I omitted a great deal, leaving a lot of white paper untouched. This white area played an important part in keeping the atmosphere pure and simple.

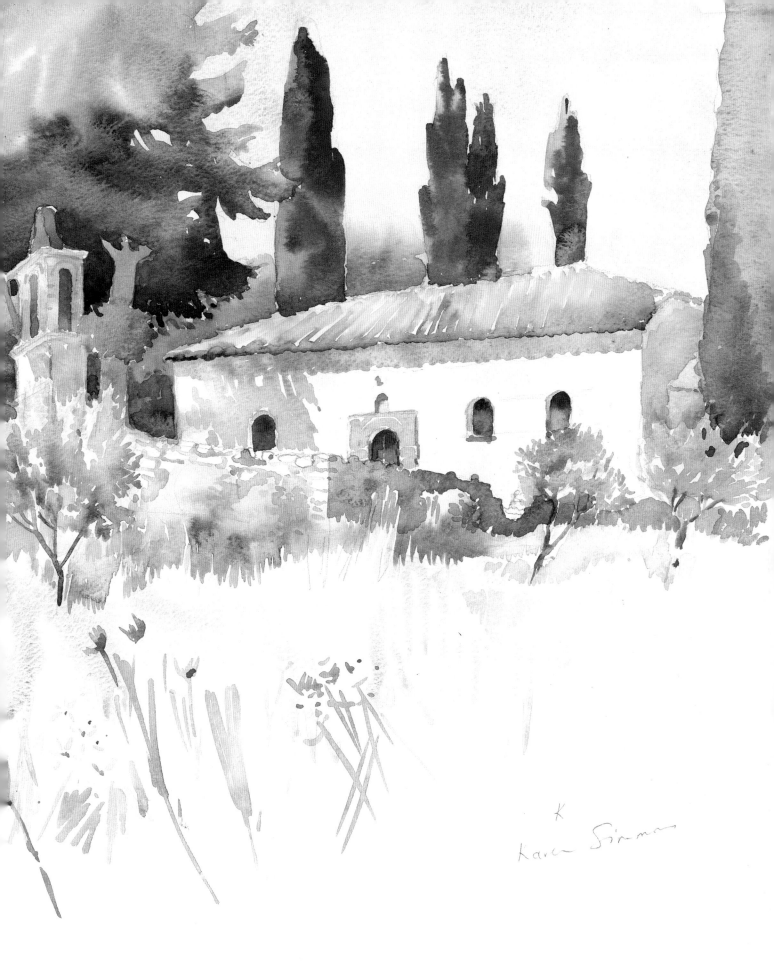

Karen Simmons

Cavo Areion

The entrance to Cavo Areion is an invitation to enter into the sun and light of western Greece.

Cavo Areion is situated in the same village as the little chapel in the previous painting and shares with this part of the world a wonderful clear light. Few painters can resist olive trees, as they offer such fantastic shapes with their twisted trunks and branches. This ancient olive stands at the entrance to the drive, framing the view to the sea and mountains beyond.

I stood at my easel, somewhat in the way of anyone coming in or going out. As it was siesta time, however, I did not anticipate many interruptions. I sketched the view, trying out various possible compositions before deciding on this one. I also studied the tonal balance of the whole scene.

The olive tree dominated my chosen composition and was the first item to be drawn. Every space shape and angle needed care if I was to do justice to its magnificent shape. I measured the end of the drive against the tree, and also the post and the horizontal line of the sea. I plotted the gap between the olive tree and the post, and the adjoining bush, and then added the other olive tree. The drawing was more of a diagram at this stage, until everything was placed.

This time I painted the trunk and branches of the big olive tree first. For the limey-green of the upward-thrusting trunk I mixed Cadmium Yellow Pale with a little Raw Umber, tempered here and there with a little Cadmium Red. Once some of the colour was in I could drop in more, letting it run down and twist with the trunk. The colour in the lower part of the tree was cool. The trunk was reflecting the colours from the shady bank of wildflowers; for this cool colour I used some Cerulean Blue mixed with Permanent Rose to make a violet, then tempered (controlled) it with a little Raw Umber. I used Raw Umber, sometimes combined with Permanent Rose, and at other times on its own, as the colour for the remaining branches. The darker ones were very dark, and for these a mixture of Raw Umber, French Ultramarine and Cadmium Red gave me the rich, deep tone I needed.

I then painted the other olive tree, complete with its foliage. The leaves of the olive tree are fine and dainty, giving an impression from a distance of a silvery cloud shadowed with gold. I used Cerulean Blue with Light Red for the silvery colour, and Cerulean Blue with a lot of Yellow Ochre for the gold colour. These pigments separate in the water and granulate, creating a textured effect. Using my big brush, with its excellent point,

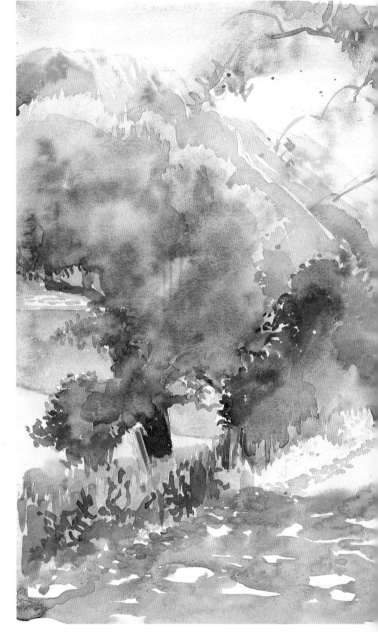

Cavo Areion
16 × 19¾ in (40·5 × 50 cm)

Detail showing the contrast between the olive tree and the post

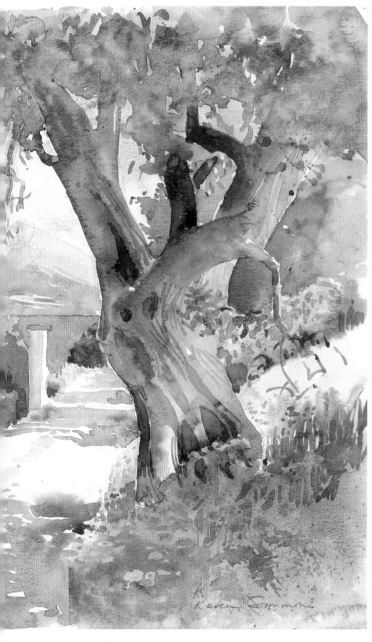

I could give the tree its dainty profile edge and flood the colour back into the mass of the tree. I deepened the colour in places to suggest the shadowed area, then added in the trunk and branches.

Next, I wetted the remaining area above the sea line and painted the sky with a very pale blue washed to a little Light Red on the horizon. The sky colour came right down to the sea. I painted in the mountain once the sky was dry; this was pale in colour, and similar in tone to the top of the smaller olive tree. Using the pinky note of the mountain to contrast with the blue-silver of the olive tree, I was able to describe both. Any dramatic contrasts here would have taken the eye away from the great olive tree.

The foliage for the main olive tree was seen mostly from below, and was therefore stronger in tone. I painted in this foliage fairly wet, using Cerulean Blue, Yellow Ochre and a little Light Red. With the tip of my brush I pulled out a few straggling twigs and a few fine leaves.

I painted the bushes to the side of the drive and behind the great olive tree in varying tones, mostly using French Ultramarine and some Cadmium Yellow.

I used Cadmium yellow for the bright sunlit grasses on the bank and for the field below. The foreground wildflowers, thistles, scabious and buttercups were just suggested. When these varied colours were dry I glazed over the whole with Cobalt Blue, to which I had added a little Permanent Rose. To glaze, the first surface needs to be really dry before the glaze is laid over it, with the brush used in one direction only.

I painted the drive, which was nearly white in the bright sun, with diluted Light Red. I shadowed the post with blue on one side and capped it with a warm red. I painted the sea, a deep blue, with Cobalt Blue combined with Cerulean Blue.

Lastly, I painted the shadows on the drive, which appeared paler in the distance and stronger in the foreground. For the shadows I used a weak solution of Light Red mottled with Cobalt Blue. In the foreground I looped the brushstrokes to trap some of the sunlight, then deepened the colour further in one or two places. Some extra dark green on the left in the foreground completed the big, cool, shadowed area which had sheltered me from the bright sun that afternoon.

The humblest holiday painting can recall the experience more vividly than any photograph. This is due to the time and the living experience it takes to do it. The cicadas, the rustle of the tortoise, the dry smell of the herbs, all come back to you from the painting.

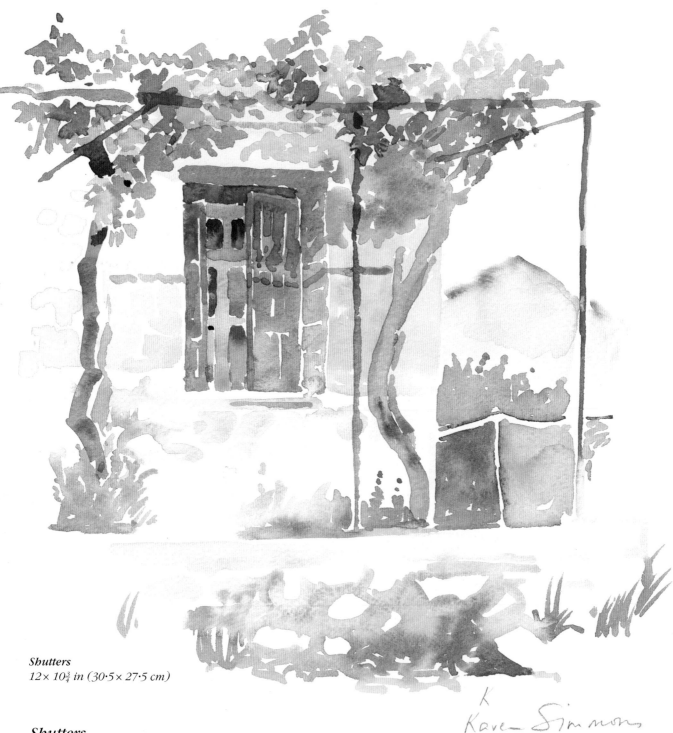

Shutters
12 × 10¾ in (30·5 × 27·5 cm)

Shutters

I painted this in twenty minutes while perched at the side of a road in western Greece. The sunset behind me was growing more spectacular by the minute. These little green shutters with the vine growing up around the house were catching the lovely light and making the exciting shadows. I went straight in with the colour, without any drawing. I arrived at my destination a little late, but I had had a good paint!

(Opposite) **Egg jar**
This jar, originally from Brunei, stood in the Australian sun. The glaze reflected the balcony, which was bleached white by the light. I used a deep Prussian Blue for the sea. The shadows, hard-edged and dramatic, were mostly French Ultramarine with Permanent Rose and some Cerulean Blue. 16½ × 16 in (42 × 40·5 cm)

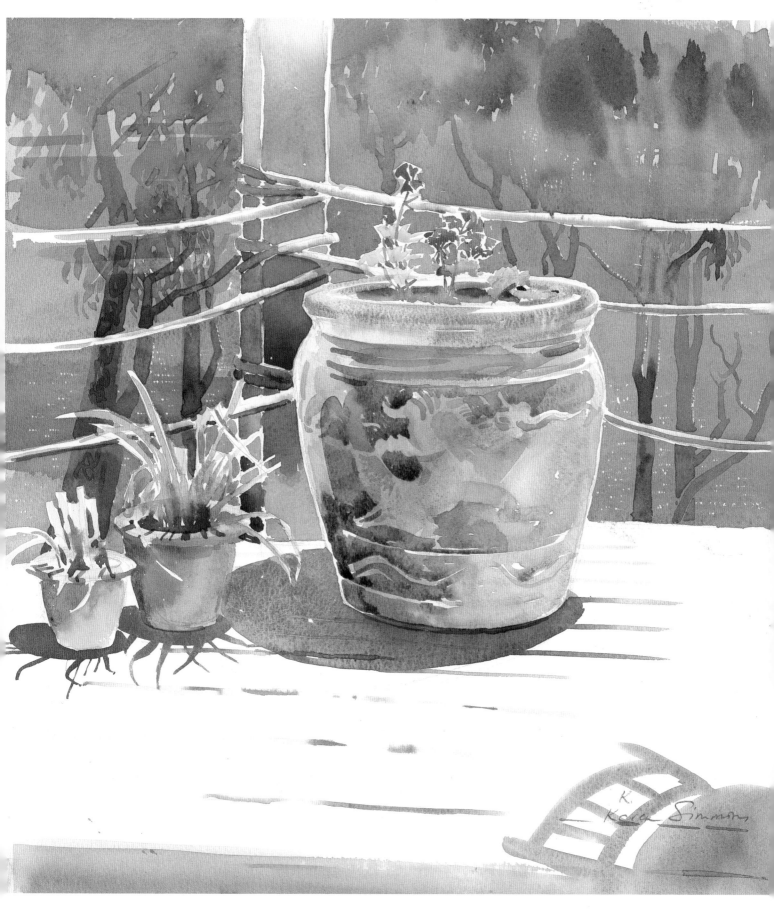

5

Colour in skies

The tone and colour of the sky dictate the tone and colour of all that lies below it. The quality of light describes the temperature, the time of day and the seasons. It is important to remember that skies have perspective, as well as the landscape (see Fig. 1 on page 21, and also *Sky at Millthorpe* on pages 52–3). To remind myself of this I start painting my sky from the horizon, upwards and outwards, the horizon being the most distant part of the painting.

Summer sky (Figs. 1 and 2)

Fig. 1 I wetted the paper first so that the wash could flow freely. Using Light Red I painted a band of this dilute colour across the horizon and allowed the colour to flow well down the paper. I added Cerulean Blue above this, and Cobalt Blue above that, and then tilted the paper to allow the colours to drain across each other downwards – in other words, mixing without the aid of the brush! This resulted in what I call a 'pearly non-colour' on the horizon, describing exactly the bright haze of a summer day.

Fig. 2 With the sky still damp, I took a clean, damp brush and lifted out some cloud shapes. I wiped my brush on a sponge, but did not use tissue paper or a sponge on the painting. There were big clouds and big spaces at the top; clouds and the spaces between the clouds closed to nothing in the distance. Having lifted out the clouds, they needed shadowing with some warm greys. I used Raw Umber, sometimes cooling the grey by adding French Ultramarine, and the two mixed together for the heavier shadows.

I shadowed the distant clouds with Light Red and a little Cobalt Blue, as the tone and the colour needed to be subtle. The underlying Light Red made a good foundation for the distant features of the landscape.

The hint of red helped to mute the blues and aided the recessive quality of the colour.

Coastal sky (Figs. 3 and 4)

Figs. 3 and 4 show a sky with fingers of light breaking through clouds. **Fig. 3** Once again I started by wetting the whole paper and dropped in some Raw Sienna, to which I added some Raw Umber, moving my brush upward at the outer edges. Just before the paper dried I lifted out the shafts of light with a near-dry brush, as well as the light on the sea below.

Fig. 4 Next, mixing Raw Umber with French Ultramarine, I painted some heavy clouds across the top of the 'fingers'.

I kept the lacy frill of the incoming sea dry, and imitated the sky colours in the sea and wet sand. I painted in the dark rocks when the rest had dried.

Sunset sky (Figs. 5 and 6)

No sunset is like any other. The fewer the colours that are used, the more powerful it will be.

Fig. 5 For the foundation colour I used Raw Sienna and Permanent Rose with a little Cerulean Blue at the top. Then, while damp, I streaked in some strands of pure Gamboge, which pushed the other colours aside. I then lifted out the white sun with the brush.

Fig. 6 Some Gamboge together with Permanent Rose made the luminous orange. I painted the clouds with French Ultramarine and Permanent Rose, which bled out realistically into the sky. I silhouetted the landscape features against the sky. They are not black, but hold in them some of the reddish colour of the sunset.

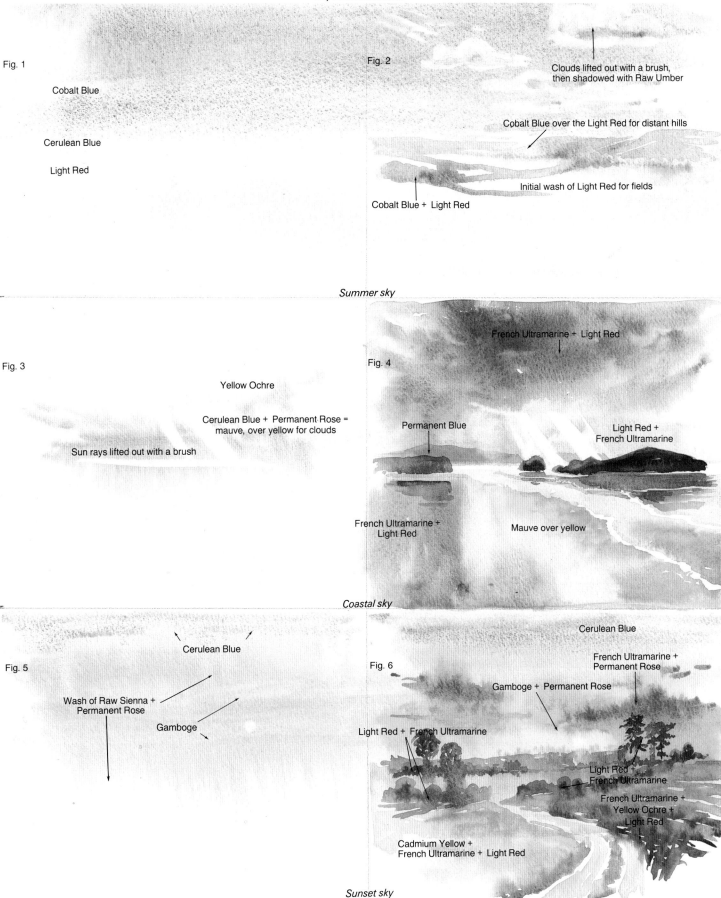

Sky demonstrations

Fig. 1

Cobalt Blue

Cerulean Blue

Light Red

Fig. 2

Clouds lifted out with a brush,
then shadowed with Raw Umber

Cobalt Blue over the Light Red for distant hills

Initial wash of Light Red for fields

Cobalt Blue + Light Red

Summer sky

Fig. 3

Yellow Ochre

Cerulean Blue + Permanent Rose =
mauve, over yellow for clouds

Sun rays lifted out with a brush

Fig. 4

French Ultramarine + Light Red

Permanent Blue

Light Red +
French Ultramarine

French Ultramarine +
Light Red

Mauve over yellow

Coastal sky

Fig. 5

Cerulean Blue

Wash of Raw Sienna +
Permanent Rose

Gamboge

Fig. 6

Cerulean Blue

French Ultramarine +
Permanent Rose

Gamboge + Permanent Rose

Light Red + French Ultramarine

Light Red +
French Ultramarine

French Ultramarine +
Yellow Ochre +
Light Red

Cadmium Yellow +
French Ultramarine + Light Red

Sunset sky

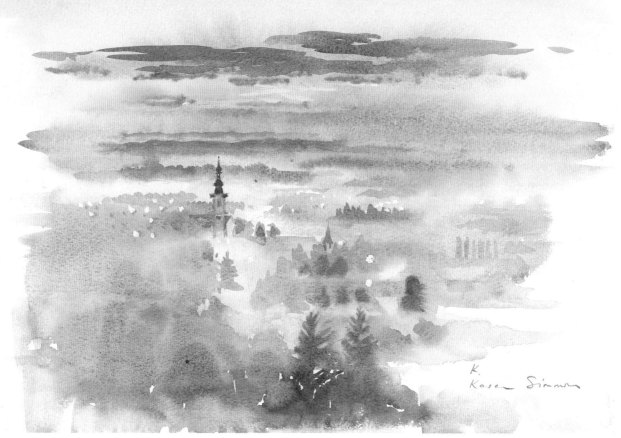

Dawn over Leibnitz 12 × 15½ in (30·5 × 39·5 cm)

Dawn over Leibnitz

From Schloss Seggau my room looked out high over Leibnitz in Austria. Early October mists blanketed the world below, but one morning as I watched the dawn, the spire started to emerge from the mist. The sky took on colour and the street lights gradually dimmed in competition with the dawn light. It was no good going back to bed: I had to try to capture the dawn.

First I preserved the street lights using a white grease crayon. The sky, dramatic with colour on the horizon, faded to pure aquamarine above. I painted the sky, first using Cadmium Yellow Pale for the distant yellow and fading to Viridian at the top. Then I painted a band of Cadmium Yellow and Permanent Rose, and streaked it with pure Permanent Rose. I painted the heavy purple clouds with French Ultramarine and Permanent Rose.

Before I had finished the mist had almost cleared, and I could discern cars moving about the streets as the Austrians, early risers that they are, were already starting their day.

Sunset at Earnley

I painted this scene in about twenty minutes. Earnley is on flat land by the sea, near Chichester in Sussex. There are often spectacular sunsets in this area. Raw Sienna, and Light Red fading to Cerulean Blue, were my foundation colours. I painted in some of the tempestuous clouds while this layer was still damp; for these I used French Ultramarine and a little Raw Umber.

I painted in Gamboge streaked with Permanent Rose just as the sun slipped down below the horizon. Some of the clouds bled rather freely, but I decided to leave them alone. I coloured the flat ploughed field with Light Red, a little French Ultramarine and, to echo the sky, a touch of Permanent Rose as well.

The frieze of roofs silhouetted against the sky was a particularly attractive feature. For these strong darks I mixed French Ultramarine, Raw Umber and Cadmium Red.

Yorkshire Moors

In contrast to dawns and sunsets this was painted mid-morning in June. The sky seemed to promise to clear, but never quite managed to do so, remaining lightly overcast all day.

I wetted the sky area generously, to well below the horizon, with a fat brush. I selected Cadmium Yellow

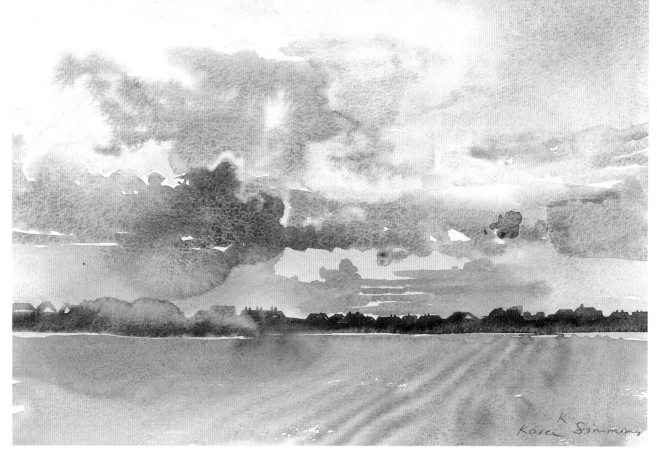

Sunset at Earnley 10½ × 14 in (27 × 35·5 cm)

Pale with Raw Sienna as the first colour to be blushed in, and allowed it to run down. I added dilute Cobalt Blue above this colour, and mixed a little of the Cobalt Blue with Light Red for the hazy cloud on the horizon. I made the deeper cloud colour with the same combination but less water. As all the clouds were hazy and without definition, I left these colours to fuse together.

Finally, I added the landscape and horned sheep, using a little pencil over-drawing.

Yorkshire Moors 10 × 14 in (25·5 × 35·5 cm)

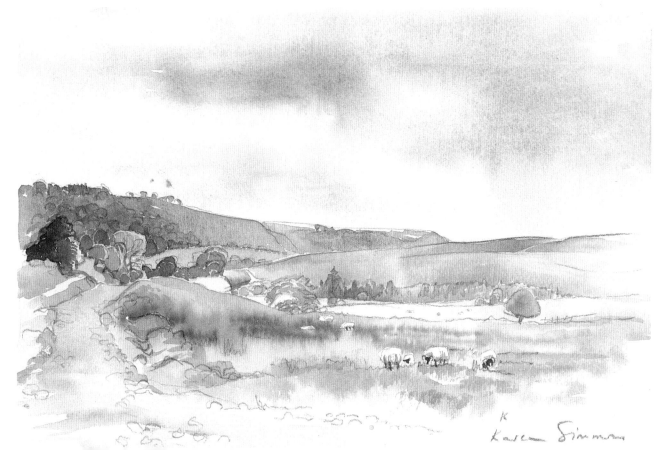

Spring floods

Following severe autumn gales the early spring brought heavy rain and floods. This was sad for farmers, but floods are lovely to paint!

I made this charcoal drawing from my car, which I parked in the sodden gateway to the field. The wind was really cold and was moving the clouds across at speed and rippling the water. The sun came and went, lighting up parts of the scene with strong bands of light, with the clouds causing shadows to race across again.

I smeared charcoal all over the sky area, and then lifted out the 'silver linings' with a putty eraser. I then deepened the tone with charcoal for the black clouds. I kept the distant landscape shapes quite shallow to preserve the feeling of perspective. I drew the dark, skeletal trees against the sky, noting the major trunks and branches. The fallen tree created an attractive reflection, so I carefully observed this branch too.

Next, I drew the islands which had been formed by the flood, and, where they were in shadow, shaded with charcoal. I marked in some water ripples, but the water itself I left largely white.

From this tonal information it would be possible to do a painting at home in comfort!

Spring floods
Tonal sketch in charcoal. $16\frac{1}{2} \times 22\frac{1}{2}$ in (42 × 57·5 cm)

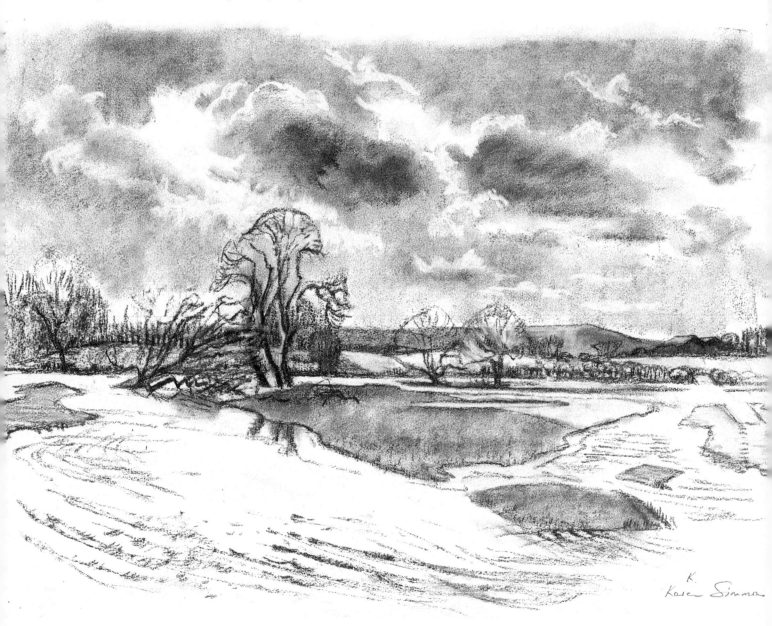

Sussex Downs
$6\frac{1}{4} \times 7\frac{1}{2}$ *in (16 × 19 cm)*

Sussex Downs

It is clear from this little painting that I took the sky colour right down to the ploughed field.

I painted the Downs once the sky had dried. I fused Light Red with some French Ultramarine, allowing a little of the sky colour to show through in places. I painted in the autumn trees while this 'blue' was still damp. I painted the field and the starlings last.

The distance and the sky are very closely related in this painting.

I painted the next three skies in Australia, where working in the open is tremendously stimulating. The light is exceptionally bright and the contrast of tones sharply defined. From the vast, open landscapes to the variety of gums and shrubs, to the simple farm buildings with verandahs and the ever-present water tanks, there is a rich source of subjects to paint.

The outdoor painter needs to be tough in Australia. Plenty of mosquito and fly repellent is essential, or one

hand is in constant use waving the distractions away. It is wise to take sun cream, a broad-brimmed hat and sensible shoes, and also plenty of water, both for you to drink and for the masterpiece. If the conditions are dry and hot, I take a cloth which I can dampen to place under my paper to keep it cool.

Evening shadows, Molly Mook, New South Wales

Along the coast south of Sydney, there are many wonderful sandy beaches. After a swim I sat on the bank overlooking the beach and enjoyed the late-afternoon sun. The gums stood tall, backed by dark pines, and I painted these, with their light trunks and sparse foliage, first.

The bright sand coloured the trunks with reflected light, turning them pink and mauve. Light Red, with a mauve made with Cerulean Blue and Permanent Rose was the blend I used. I also let this spill on to the surrounding bank. I painted the light foliage at the top of the gums with Cadmium Yellow and very little additional Cerulean Blue.

The denser bushes below were a rich green, which I made with French Ultramarine and a lot of Cadmium Yellow, echoing the reflected light with some more Light Red. I painted the pines behind with the same colours but with a thicker mixture.

I painted the sky at this stage, firstly with a band of Gamboge on the horizon, followed by a weak Cerulean Blue above it. I then deepened the sky at the top with French Ultramarine, to which I had added a very small amount of Permanent Rose to make an altogether finer deep blue.

I painted the sea with Cerulean Blue and a little French Ultramarine, changing to pure Cerulean Blue for the shallower water. For the beach, I patterned the sand with a wet brush and then added some dilute Light Red.

The long shadows followed the ruffled beach, reaching almost to the sea. I used a weak solution of French Ultramarine, Permanent Rose and a little Light Red. I kept the warmer colours to the foreground, allowing more purple into the distant shadows.

Evening shadows, Molly Mook, New South Wales
16 × 19¾ in (40·5 × 50 cm)

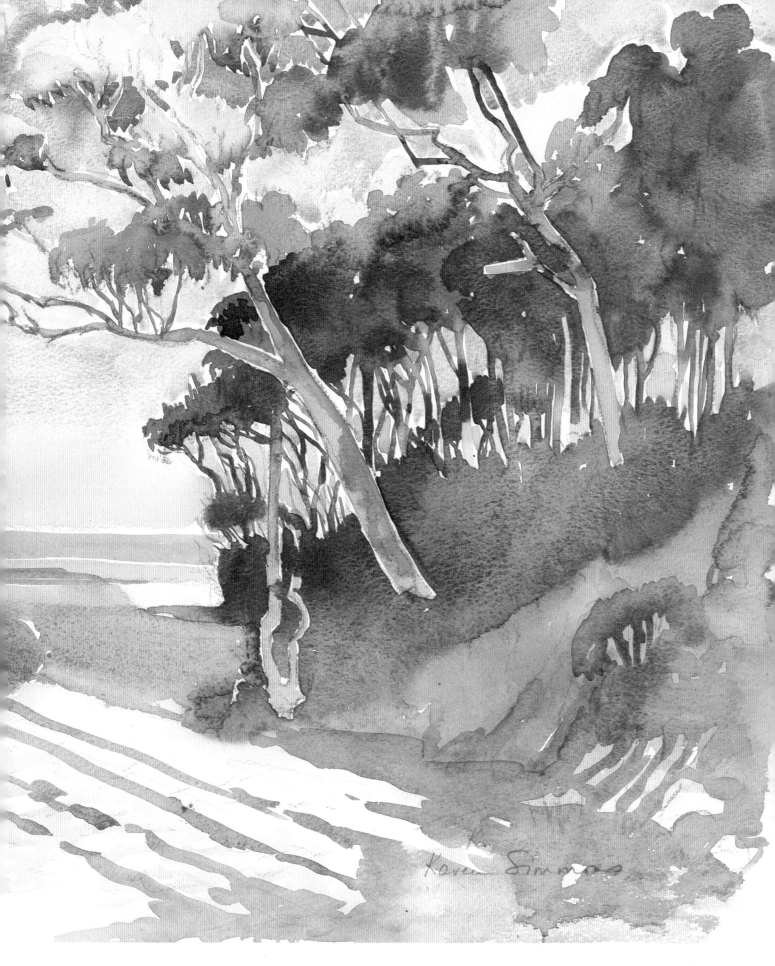

Karen Simmons

Storm over Jindabyne, New South Wales

Lake Jindabyne lies in the foothills to the Snowy Mountains in New South Wales. I had to paint this very quickly as the oncoming storm was moving fast across the once-tranquil lake. The blond grasses and the red-tinted earth, sand and rocks of the foreground contrasted sharply with the dark sky and the distant inky mountains.

I washed in a lot of the foreground with diluted Raw Umber, Yellow Ochre and Light Red, along with a pinky wash for the low hills on the far shore. While this was drying I quickly wetted the sky area (all but the lower right-hand corner) and then flooded in a mixture of Raw Umber and French Ultramarine with a touch of Yellow Ochre at the edge. For the clouds that were darker still, I used the same mixture but with less water.

The far mountains just showing on the right were a jewelled Prussian Blue. For the inky dark mountains I could have used Indigo if I had had it in my palette, but used French Ultramarine, Permanent Rose and a touch of Light Red instead.

When needing to paint dark colours in watercolour, take courage – the tone does weaken as it dries. Being over-cautious in this painting would have lost the drama.

By then it was time to dash, as great drops of rain were coming down and I was drenched before reaching shelter. I put the painting inside the trusty dustbin bag, however, so all was well. Back to base and dry again, I painted in the lake.

Using Cerulean Blue, French Ultramarine and Raw Umber for the deeper tone of the lake, I invaded the grasses, cutting them out to bring them forward. Leaving the lake pale where it reflected the patch of bright sky, I painted a reddish colour on the right, echoing the red hills which were richly dark from cloud shadow. I then added some of the wildflowers in the foreground and the shadowed sides to the rocks, keeping their top facets light.

Storm over Jindabyne, New South Wales
16 × 19¾ in (40·5 × 50 cm)

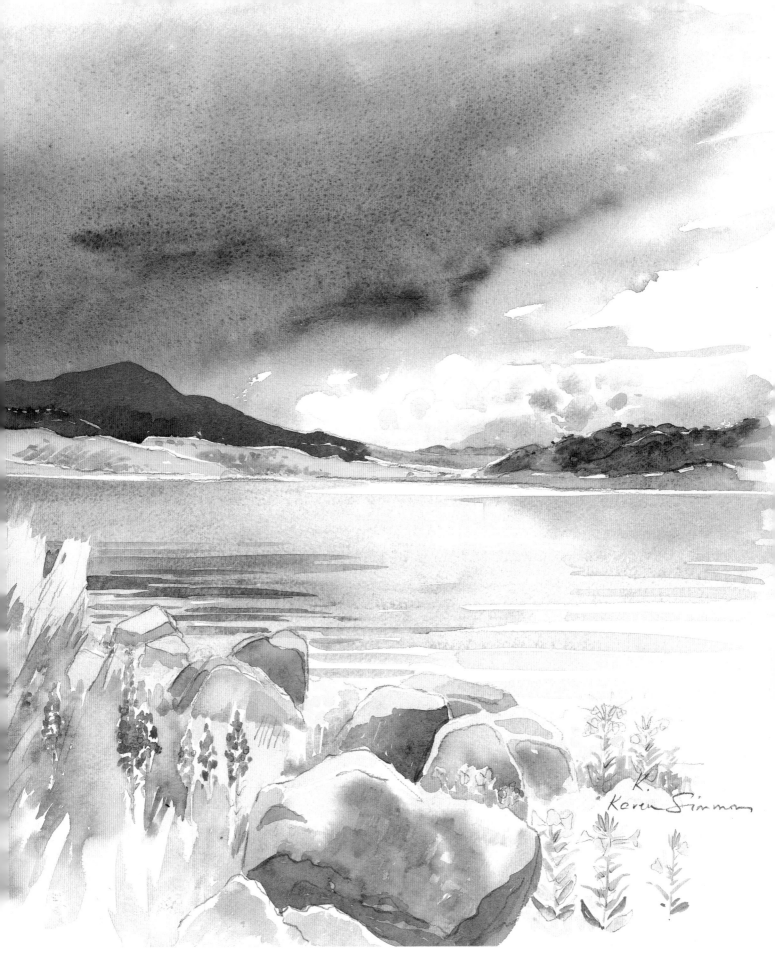

Sky at Millthorpe, New South Wales

What strikes one in Australia – apart from the crisp, dazzling light – is the sky, which is vast, stretching to infinity. This subject was dramatic, and the skyscape typical of this part of Australia. I painted the clouds pulsating towards me against the light, one of my favourite themes.

This time there was no pre-wetting of the sky as I needed some bright edges to the clouds. I wetted large, untidy patches for the overhead clouds and dropped in some Raw Umber, followed by Raw Umber with French Ultramarine varying from warm to cold and darker grey. One does need to be bold, and with water already on the paper the pigment should be fairly dense.

Having established a few of the bigger clouds, I carried on down the sky. Both the clouds and the sky intervals diminished in size into the far far distance where Mount Canobolas showed on the horizon.

As it was late afternoon there was already a pinky light in the lower sky, and for this I washed in dilute Light Red. I touched in the strips of clouds in grey-pink, using Cobalt Blue, Permanent Rose and a little Light Red in varying amounts. I painted Mount Canobolas over the Light Red when it was dry, using French Ultramarine and Permanent Rose.

I then turned my attention back to the overhead sky. For the deep blue intervals I used French Ultramarine with, once again, a touch of Permanent Rose. This gave an airy deep blue without being garish. I then gradually added Cerulean Blue for the mid-sky blues, all the time keeping the bright white ragged margin to the clouds dry and untouched.

The old woolshed on the left was a strong, dark shape with a hint of reflected light in the rafters. The bales of hay were stacked in shadow, and the different shapes and colours shared a similar tone.

The grass below, with the strong light glowing through it, became a vivid lemon yellow while the shadowed grass showed in dark contrast.

The gum trees against the light had glowing haloes. I painted these with Raw Umber, Yellow Ochre and a little French Ultramarine, then touched the tops again with more yellow while wet so that the aggressive yellow pushed back the darker tone. The light on this landscape was so bright it glittered.

Sky at Millthorpe, New South Wales
22½ × 31 in (57·5 × 79 cm)

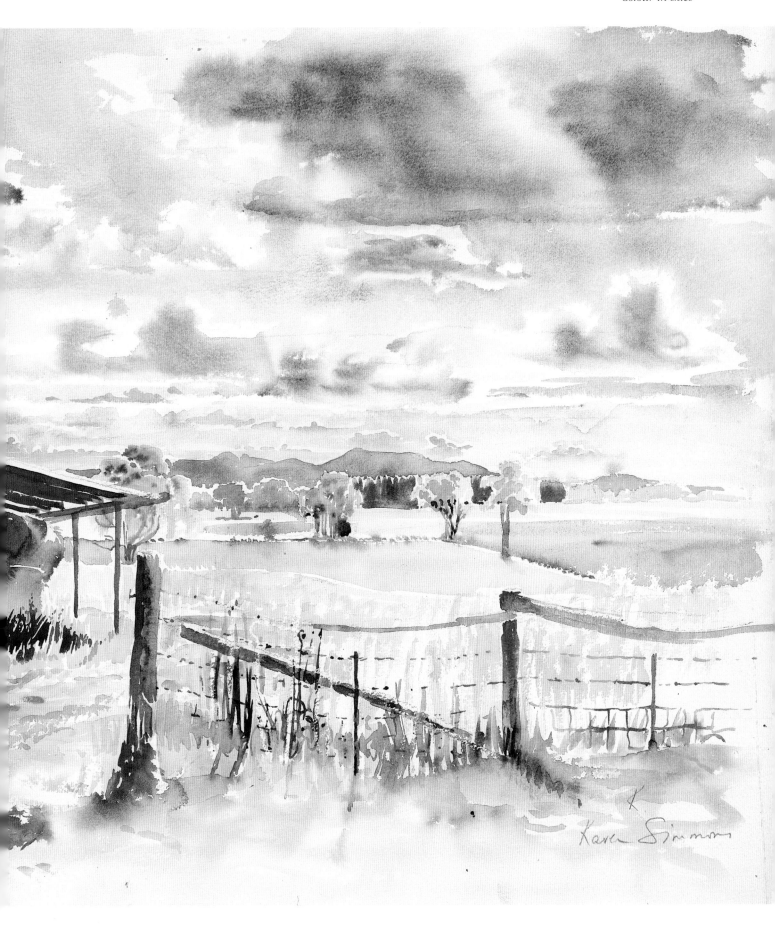

6

Colour in waterscapes

Water in all its forms has always been a popular subject for painting. Many people find refreshment in a picture that has water in it. The sparkling stream; the still lake with reflections; even a puddle with its upside-down world provides an enticing challenge. As with so much of painting, the less you do the more effective a waterscape will be.

Water demonstrations

Fig. 1 Stream

Water gushing over or around stones may be combed into rods, but it is better to ignore most of the grooves, keeping only the main ones. By sacrificing most of the grooves and preserving larger areas of white, the rippling water will have more sparkle and impact in the painting.

Fig. 2 Reflections

For still water with reflections, and even slightly broken water showing reflection, take the brush downwards first, holding it sideways. Sometimes I wet the paper in the water area first, then brush the colours downwards and let them blend together gently. At other times I paint the colours in with a loaded brush, still downwards, adding each colour beside the previous one in quick succession and again allowing them to blend softly. The slight ensuing blur can look very watery.

Finally, if required, a few cross-ripples can be added. If there is any movement in the water the reflections will become extended.

Fig. 3 Still-water reflections

Mirror-still water will reflect the same proportions as the subject, though not necessarily quite the same view. What becomes reflected is what the water 'sees'.

Fig. 4 Reflections in disturbed water

When the water is disturbed the reflection becomes broken up and elongated.

Fig. 5 Criss-cross ripples

To create the effect of criss-cross ripples I prepare first with a wet brush, then drop in the appropriate colours, allowing the colour to travel at will. Sometimes reflections will seem to leapfrog across the ripples.

Fig. 6 Looped ripples

I prepare these too, first using a wet brush to make the loops, and then allowing the colours to flow along the prepared pattern. Different colours become trapped inside the ellipses – a fact that I learned from observation and from Monet.

(Opposite) Water demonstrations

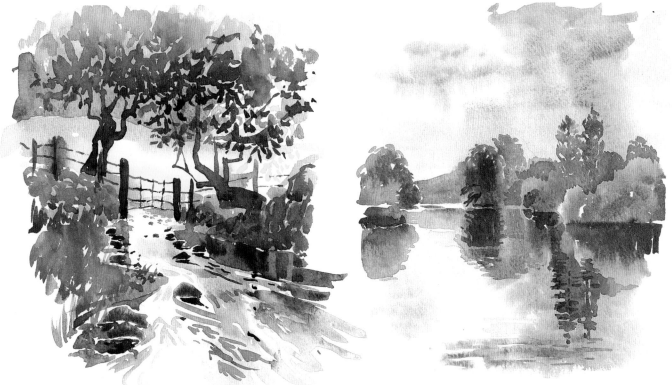

Fig. 1: stream

Fig. 2: reflections

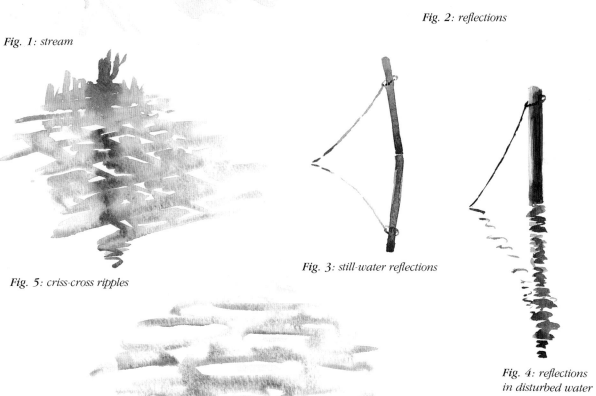

Fig. 5: criss-cross ripples

Fig. 3: still-water reflections

Fig. 4: reflections in disturbed water

Fig. 6: looped ripples

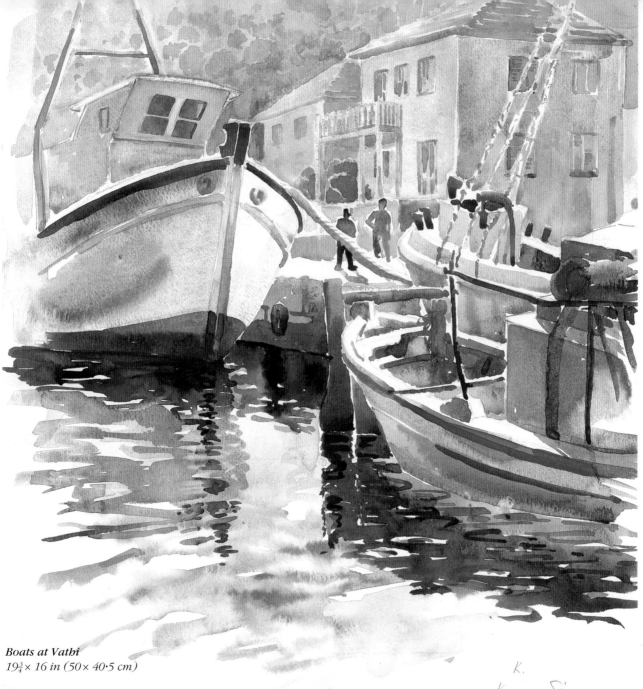

Boats at Vathi
19¾ × 16 in (50 × 40·5 cm)

K.
Karen Simmons

Boats at Vathi

The gap between the prows of these brightly painted Greek boats made an enticing shape in which the rich colours were reflected.

In bright sunshine, not only does downward light bleach colour, but reflected light also works its magic on the shadowed colours. At no point can colour be taken for granted. No colour merely 'is' but needs to be painted for what it *appears* to be. Learning to accept what the eye sees can make such a difference to a painting. Giving thought to the composition is also worthwhile and can prevent disappointments.

Having decided that it was the reflections that were my 'story', I used the paper vertically and placed the hulls in such a way that I had room for the spill of colour in the foreground water.

Boat shapes vary from country to country and need careful drawing to be convincing. Checking the space shapes can help to keep one on course. Sketches and photographs of boats are a help, as it often happens that the very boat you are painting (which has been in harbour for days) immediately sets out to sea. In this case, just as I was about to paint the reflections another boat came in and totally blocked my view. I then had to scramble aboard one of the other boats to finish as best I could.

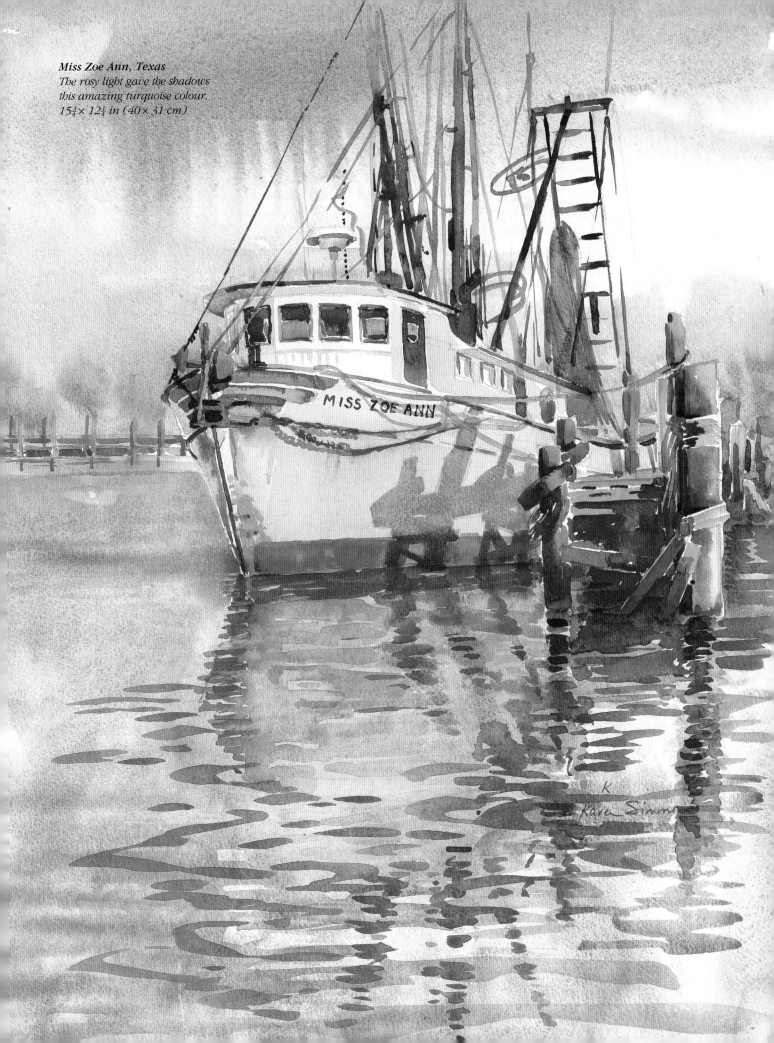

Miss Zoe Ann, Texas
The rosy light gave the shadows
this amazing turquoise colour.
$15\frac{3}{4} \times 12\frac{1}{4}$ *in* (40 × 31 *cm*)

MISS ZOE ANN

Rocks and water, St John's, Greece

Instead of painting the whole headland, I chose a group of rocks with an eye to the rhythm at the base, allowing room for me to enjoy the jade-green sea.

Painting rocks can be a hazard as one is very conscious of all the fissures that craze the surface. Before worrying about the detail I try to establish the volume and the main facets by tone, i.e., the light and dark of the block. In this case, the light being very bright, I kept the light areas white. I wetted the rest and mottled the colours to suggest the various changes from pink to grey-blue, also noting that there was some reflected light on the forward-facing facets.

This mottling already suggests some texture, and allows one to deepen the tone and selectively to add some cracks, dips and bumps! The cast shadow can also give an indication of the surface. Half-closing the eyes eliminates some of the detail: those details that are still visible are important enough to put in. I used Yellow Ochre, Raw Umber, Light Red and Cobalt Blue, varying the amounts and combinations.

For the stones and pebbles I first scribbled the shapes with a wet brush, and then dropped in some pinks (Light Red) and blues (Cobalt) to give the impression of pebbles.

The water was very beautiful, becoming glassy over the stones and pebbles below. I own to having a couple of tries to get something of the effect. First I painted some of the stones and intervals between the stones. When this was dry, and with a full brush flowing *down* the paper, I washed in the reflections, varying the green from jade to emerald. I used Cadmium Lemon Yellow with Cerulean Blue for the bright jade green, varying it to pure Cerulean Blue and then deepening with pure Prussian Blue, with some additional Yellow Ochre, where the rocks shimmered in the water. Having taken the colours down the page I then took my brush across to indicate the wave movement. As the paint began to dry I could just accent it here and there.

At my first attempt, I had played with the colour too much and overdone the accents, so, when back at base, I washed it out by wetting the sea area generously. Then (firstly counting up to ten) I put the whole work under the tap and gently eased the pigment off with a soft brush. There was no need to get back to white paper, so I was happy to keep the staining from the Prussian Blue and was pleased that the pebbles and stones had survived sufficiently. Allowing this to dry completely, I started again and remembered to be more restrained.

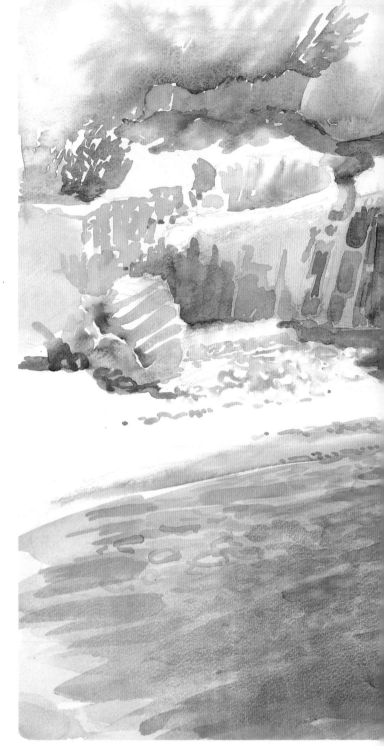

Rocks and water, St Johns, Greece
$16 \times 19\frac{3}{4}$ in ($40 \cdot 5 \times 50$ cm)

For this painting and for *Boats at Vathi* on page 56, I was working in the hot sun and found that placing a damp cloth underneath the paper and clamping it all to a board was an enormous help. As the water evaporates from the cloth it keeps the paper cool and makes a watercolour in hot conditions still possible.

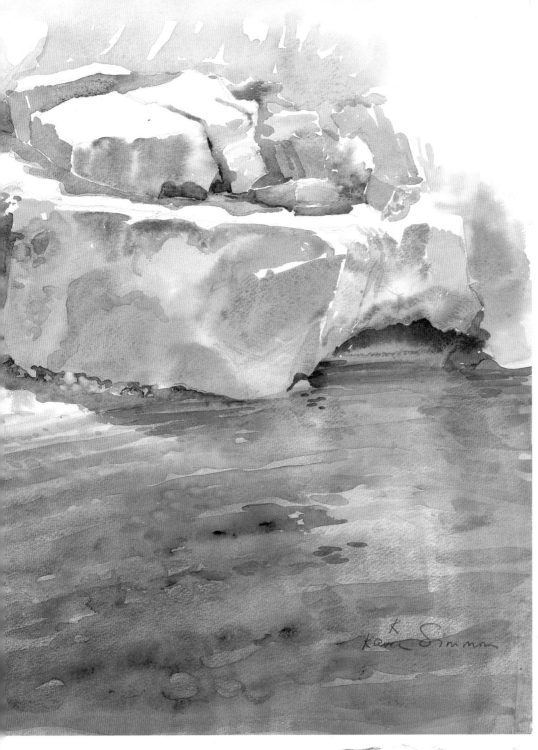

Detail of some of the rocks

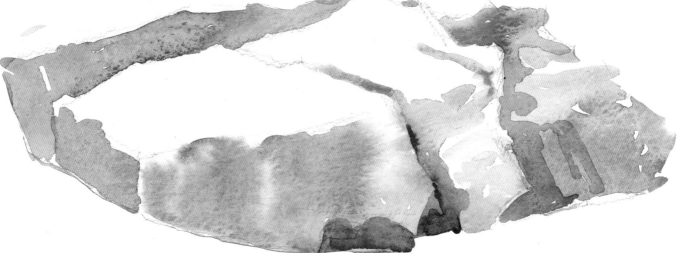

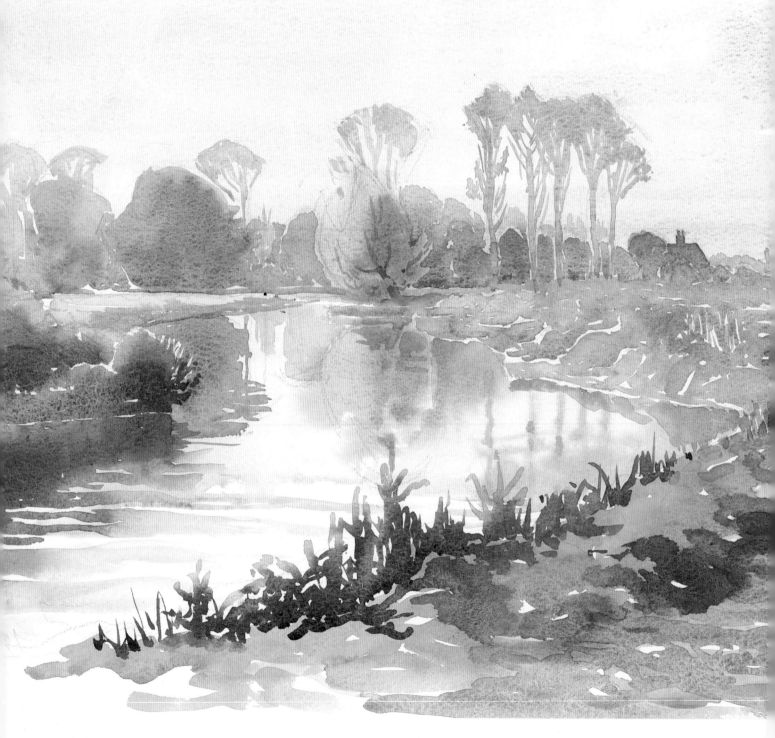

Watermeadows at Winchester
16 × 19¾ in (40·5 × 50 cm)

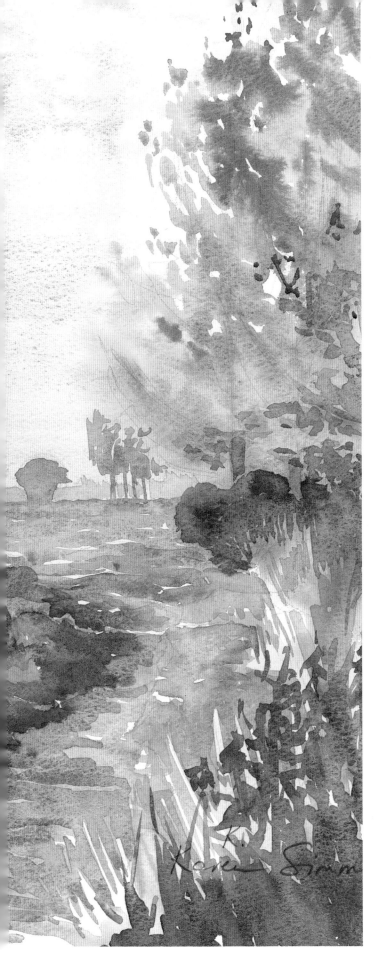

Watermeadows at Winchester

Very little drawing was necessary here but I did plot the horizon, the shallow curve to the water, and, with care, drew the rounded golden tree with its reflection. I then wetted the entire page and flooded in dilute Raw Sienna with some Light Red. I let this run down the page and, while it was still damp, indicated the soft cloud patterns with a little Cerulean Blue.

I also started the trees on the right-hand side while this first stage was still damp so that there were some soft, out-of-focus joins. I added the crisper texture as it dried. I then painted the trees on the horizon, varying the grey effect with yellows, pinks and blues, and then the little golden tree, shadowing it to give the rounded shape. Once this was dry I could deepen the tone behind the tree a little, silhouetting the house at the same time.

The water was already tinted with that first wash, so I re-wetted it and, while damp, put in the distant reflections by bringing the brush downwards. The foreground reflections were a deeper tone, and for these I used Light Red downwards and then across to indicate a few ripples. I added some French Ultramarine with a very small amount of Yellow Ochre into the Light Red close to the bank. An enlarged detail of the water and reflections can be seen on page 68.

The banks facing the low sun were a golden yellow; I used Cadmium Yellow for these. The flat meadows facing the sky were much cooler, so I used Cerulean Blue with just a touch of Yellow Ochre. The foreground banks were mostly Yellow Ochre deepened with French Ultramarine. The path, also sky-related in colour, was a mixture of Cerulean Blue, Permanent Rose and Light Red.

This was a very tranquil scene with its mellow autumn colouring.

Dawn on the Tamar (see pages 64–5)

I was on the dew-sodden riverbank before sunrise for this painting. It was quite cold, though later that day it became really warm. The scene before me was so beautiful that it was difficult to remember to paint! As the sun started to colour the tops of the trees, the light and colour changed rapidly.

I wetted the page down to the riverbank only, and dropped in Raw Sienna and Light Red, above which I painted in a dilute Viridian. I have noticed in Devon and in the west of England that the sky at dawn and dusk does sometimes contain this luminous green.

I then needed to exercise patience as the painting was very slow to dry. Once it was dry enough, I painted in the trees as one profile, keeping the delicate edges and using Yellow Ochre and Cerulean Blue for maximum granulation and textured effect. I also added more Yellow Ochre to the tree tops. When this first layer was dry, I re-cut some profiles by shading the tree behind, using much the same colour combination as before, but less water. I gave the tones that were deeper still some additional French Ultramarine.

The trees in shadow were a cool silvery-green, but the deeper tones for their underskirts were warm, so I used more Yellow Ochre and Raw Umber. Further away along the bank I painted the trees with less green, using Raw Umber with Cerulean Blue and changing to Raw Umber with French Ultramarine for the cooler grey.

I kept a few dry areas for the ripples and broken water, then wetted the rest and, bringing the brush downwards, used the sky colour again, and then the colours from the trees with some additional Yellow Ochre. As this dried I was able to deepen the colour in places, interrupting it for the ripples of the current.

When I had started, the landscape between the trees was obscured by the rising mist. Later on this cleared, but I kept the misty look to describe the dawn. It had been hard to get up at five o'clock but I was very glad that I did.

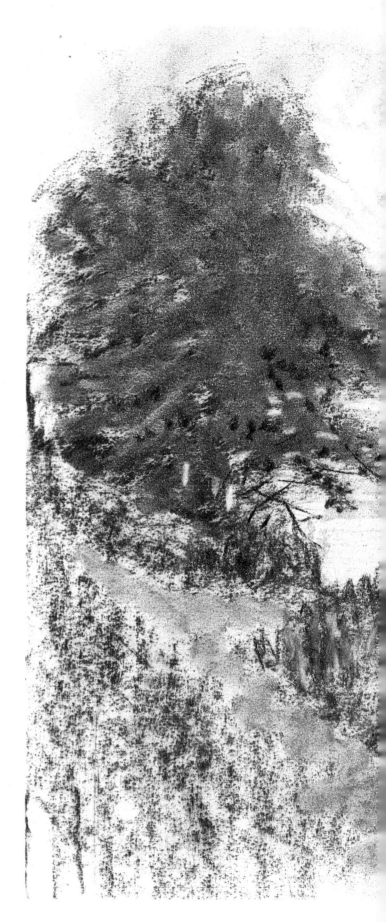

Tree detail from the charcoal sketch

*Preparatory charcoal sketch for **Dawn on the Tamar** (overleaf). Note the above detail of one of the trees on the riverbank*
Charcoal. 16½ × 21½ in (42 × 55 cm)

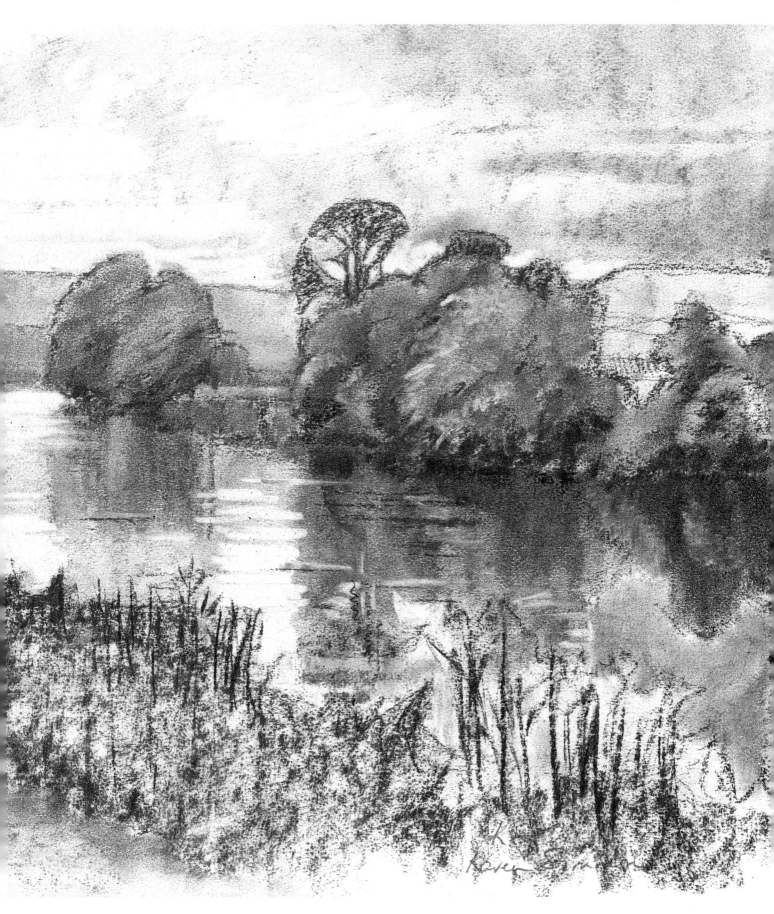

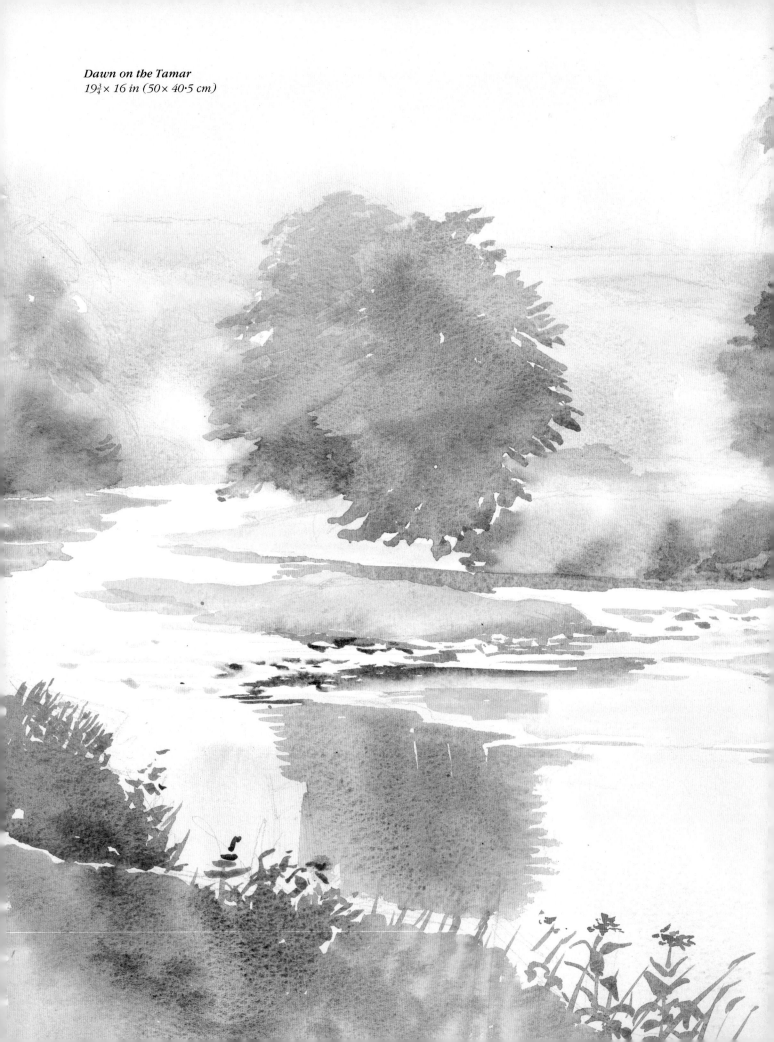

Dawn on the Tamar
19¾ × 16 in (50 × 40·5 cm)

Puddles at Minskip
4 × 5½ in (10 × 14 cm)

Puddles in the thaw

Puddles are always fun to paint, but these were dramatic. While out for a paint before the snow disappeared I was first fascinated by the sun coming through the trees and the way it melted the branches. Then those puddles caught my eye and I had to paint them. Using the paper vertically, I wet through the first two hills, keeping the very white meadows, the foreground and the disc of the sun dry. Then I washed in Yellow Ochre, a little Light Red on the horizon and some Cerulean Blue at the top.

While this was damp, I started some of the branches of the trees, still using Yellow Ochre and Light Red. Jumping back to the distant Downs, I painted in some Cerulean Blue over the Light Red; this made a very soft, fuzzy join on the hill line which was appropriate here.

Going back to the trees, I deepened the tones by introducing some blues, French Ultramarine and more Light Red at full strength. I painted the brushwood on

(Opposite) **Puddles in the thaw**
19¾ × 16 in (50 × 40·5 cm)

the left and the trees in the distance with a weaker colour first, then darkened it to bring it up to the desired tone.

The snow was only pure white in places, which I kept dry. I also left the puddles untouched at this stage.

With a full brush and dilute Light Red and Yellow Ochre, I brought the colour forward along the tracks in the road. Mixing the same colours to a deeper orange, I tinted the snow where it was reflecting the setting sun. Using French Ultramarine, Cerulean Blue and Permanent Rose to make the violets, I then brought the shadows across the road. I painted the fence and hedge gently at first, and added a few stronger accents while wet.

Lastly, obeying what my eye observed in the puddles, I painted what I saw. As the puddles were at a different angle to the trees than my view, they reflected a deeper tone.

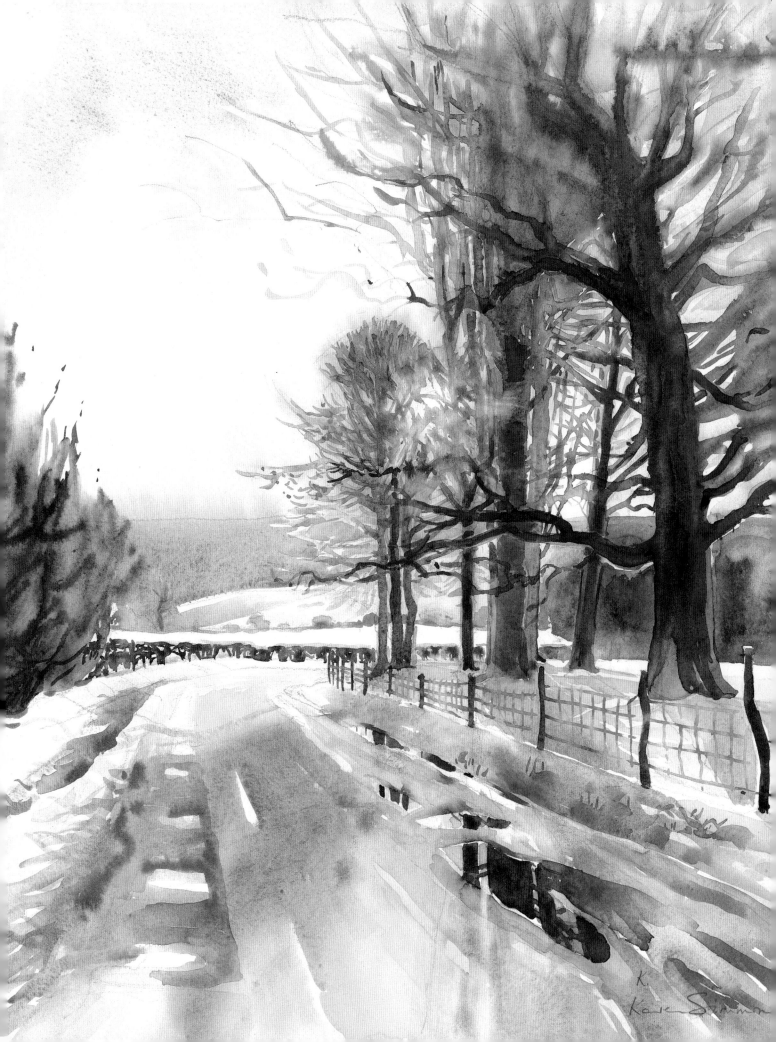

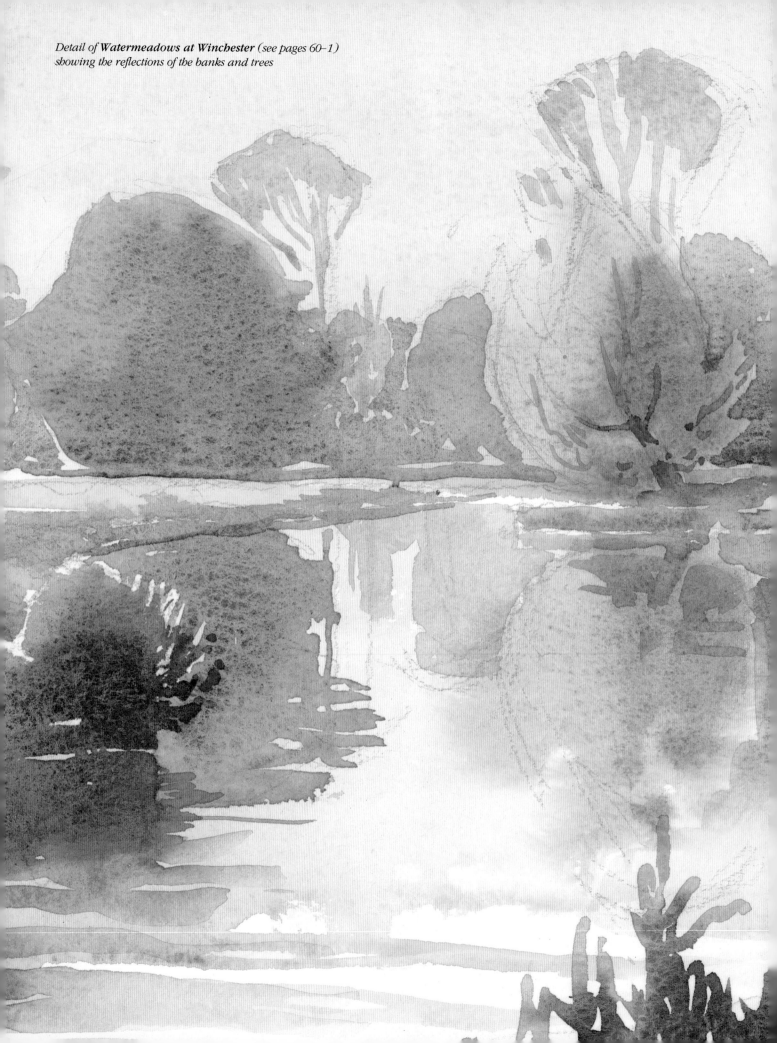

*Detail of **Watermeadows at Winchester** (see pages 60–1)
showing the reflections of the banks and trees*

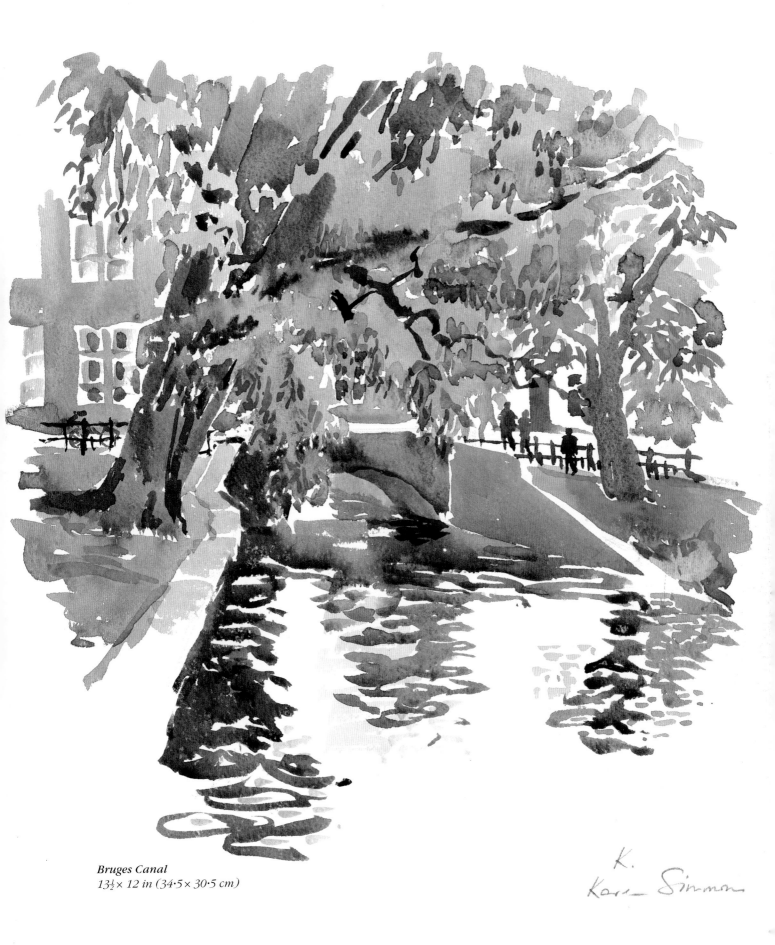

Bruges Canal
$13\frac{1}{2} \times 12$ *in* $(34 \cdot 5 \times 30 \cdot 5 \text{ cm})$

K.
Karen Simmon

7

Colour in wildflowers

The colour of flowers in the natural light is utterly different to seeing the colours in an interior setting. I do enjoy painting flowers in the house, but with the inevitable container the painting becomes a still life with flowers. Although a lovely subject, this is very different to painting flowers in their natural setting.

Under the open sky, the downward light bleaches colour, picking up the sheen and glitter of leaves. It also penetrates petals, giving a stained-glass-window effect that enriches the colour and provides dramatic contrasts. Sunlight on leaves changes the green to a cool green and sometimes even blue, while the sun coming through a leaf creates a translucent yellow-green. Only when the leaf is at a vertical angle do you

see the leaf's own true colour. These changing colours on both petals and leaves describe their shape and form (see the illustration on page 17).

The stems and leaves of flowers growing in the garden or wild in the meadow are seen at their natural angles, which allows one to respect their own design. It is also delightful to see them in their natural settings, growing amongst their own kind.

Mimulus (see pages 72–3)

These clusters of intense yellow were visible at intervals on this stretch of the South Tyne, near the borders of Cumbria and Northumberland. I was fascinated. What were they? Clambering down the bank to the rocks on the edge of the river I discovered that they were mimulus (also known as musk). Would

Pencil study for **Mimulus***, showing water detail.*
6 × 8 in (15 × 20·5 cm)

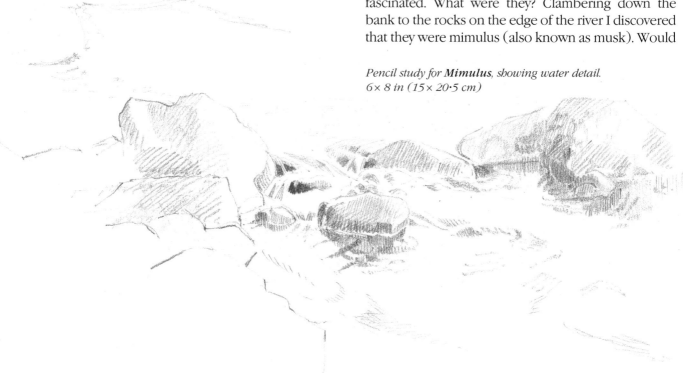

it be possible to capture that glowing yellow? What about those rocks and the stones? Always telling everyone else to keep it simple ('Don't try to put it all in'), I fell greedily into the trap of trying to do just that.

I planned out the group of mimulus and the major rocks and stones, but the water patterns needed more careful study. I picked up my sketchbook and made a pencil drawing of the little spurt of water between the stones and the patterns of the following eddies. Over the next couple of days I returned in the late afternoon and painted the picture.

The mimulus became lost in each other, the interior of the group glowing with a deeper yellow and even tinting the stones below. The neighbouring stones – some mossy and some bare – carried a variety of colours from olive green to a lovely violet which seemed to enhance the vivid yellow. The light on the water was bleached almost white, and only in the rock reflections were the peaty brown and green to be seen. The ripples seemed to be a mauvy colour, deepening

to blue just at my feet. Later, looking at the painting, I could recall the peace and the sound of the gurgling water – and forget the mosquitoes!

For the yellows of the mimulus I used Cadmium Yellow Pale, with Gamboge for the deeper tones. Gamboge with a touch of Permanent Rose made a lively orange. I painted the leaves with Cerulean Blue and Cadmium Yellow. For the rocks I used Cobalt Blue and Permanent Rose, tempered with a little yellow. I made the olive green with a mixture of Raw Umber and Cadmium Yellow Pale. The water ripples which had a mauvy tint were Cobalt Blue with a very small amount of Permanent Rose. The reflections were mostly the same olive green, as before, with some additional Light Red.

Detail of the finished painting overleaf, which was developed from the pencil study shown opposite

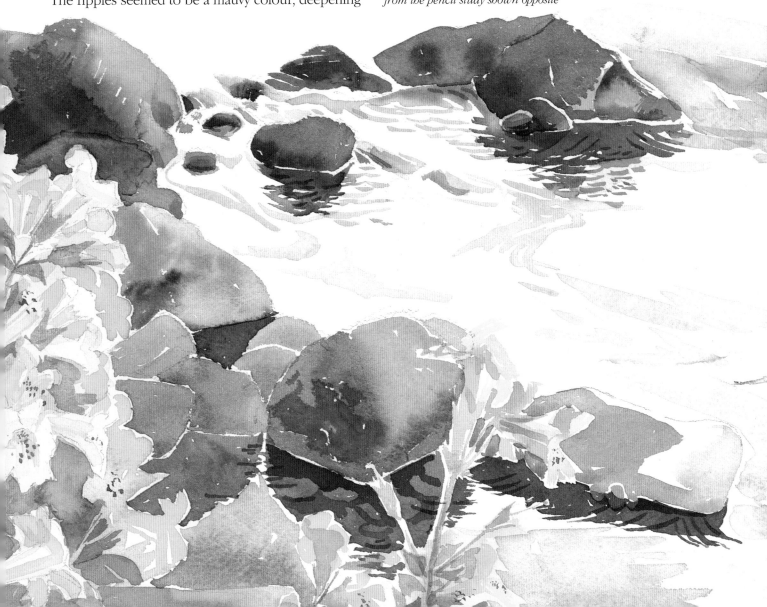

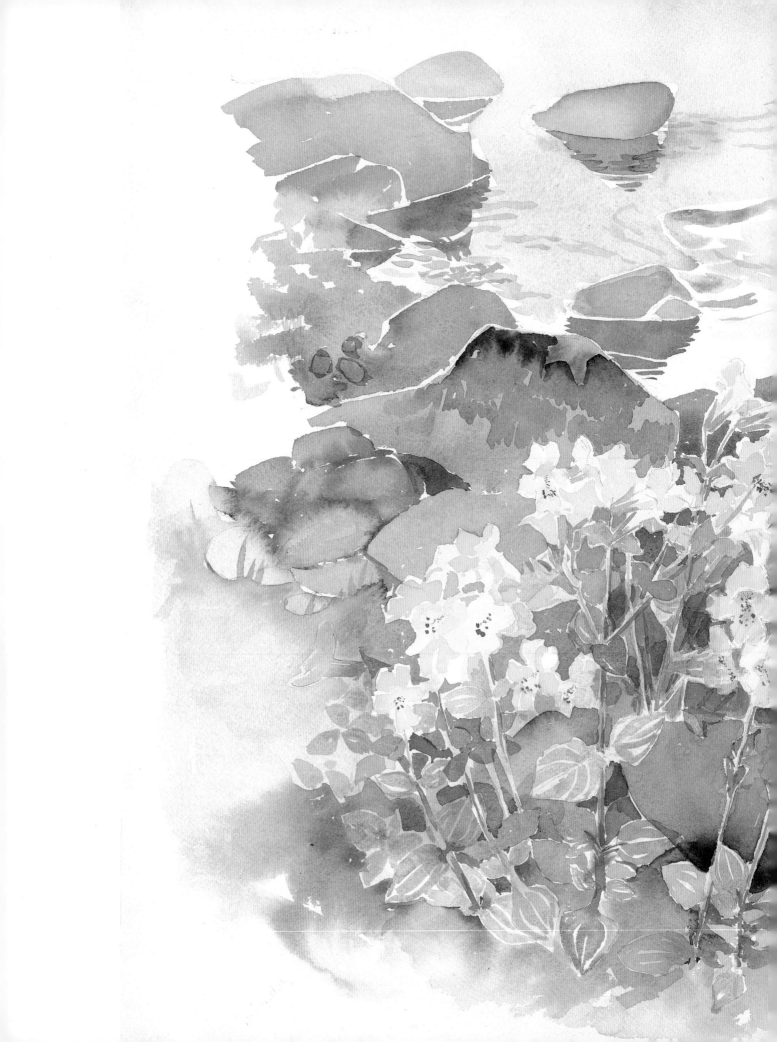

Mimulus
18 × 24 in (46 × 61 cm)

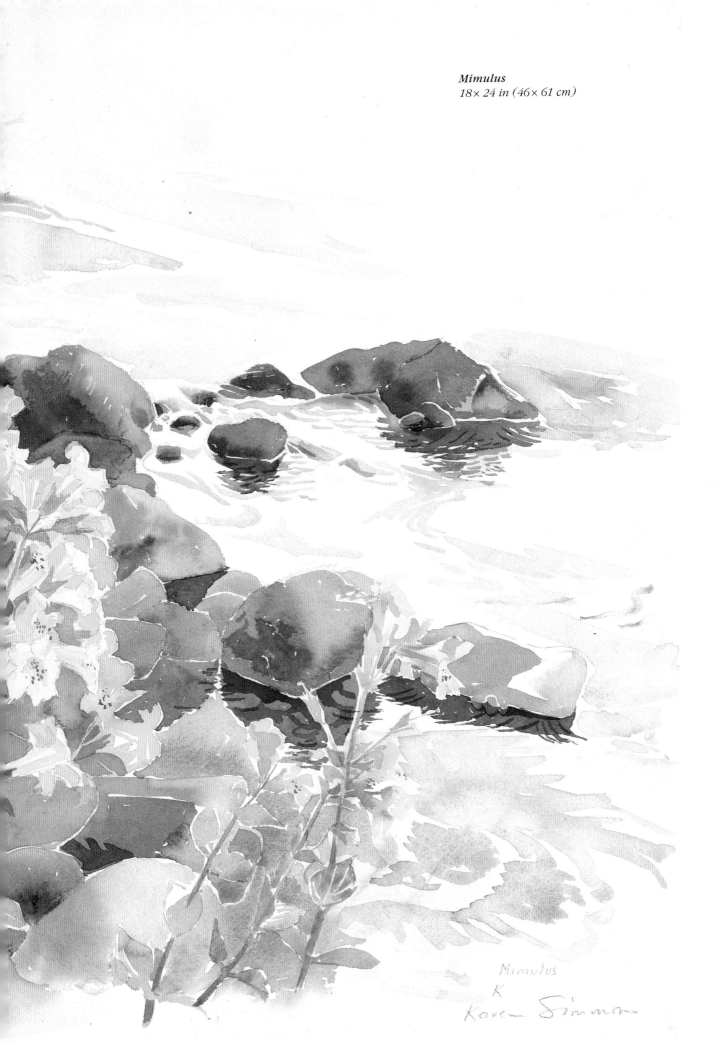

Mimulus

K

Karen Simmons

Daisy heads

Painting flowers where they grow can take one into ditches, banks and hedgerows. It can also lead one into problems of composition, as the jungle of flowers, plants, weeds and grasses is often bewildering.

Stage 1 *Plotting diagram*

After staring at a patch of moon daisies for a while, I 'saw' a group that could give me a pleasing composition. In this stage you can see how I made a diagrammatic shape of the group as a whole, along with an inner group. This plotting approach shows one straight away how the composition can be placed on the paper.

Next, I boxed the daisy heads, and noted the gap shapes in the petals. Drawing the yellow centres in relation to the front edge of the daisy was an additional aid to getting the daisy heads in perspective.

Flower stems growing naturally are well worth respecting. If they are curved, draw the curve with a series of straight lines and then soften them into a curve. The stem will then have a convincing curve, not a weak or floppy one – or, worst of all, an 'artistic' curve! The stems also establish a rhythm in the painting.

Stage 2 *The blushing technique*

This method evolved during my studies of wildflowers. I noticed how wildflowers tend to grow with their own kind: buttercups with buttercups, clover with clover, speedwell with speedwell and so on, creating pools of colour.

In this painting I used masking fluid, painting the daisy heads with a brush kept for the purpose and really shaping the heads and petals. This preserves the white daisy shape while blushing in the colour. A brush used for masking fluid needs to be rinsed out straight away.

Once the masking fluid was dry, I wetted the entire paper generously. Into the appropriate areas I blushed in yellow (Cadmium Yellow), pink (Permanent Rose), blue (Cobalt) and a little dull green, using French Ultramarine with Yellow Ochre. While this was still damp I suggested the sorrel, using Light Red with a touch of Permanent Rose. I let these colours expand in the water to granulate and fuse together gently.

When the paper was well and truly dry I rubbed the masking fluid off with a clean eraser. A clean thumb would do instead! I painted the daisy centres with pale yellow first, adding a deeper yellow at the base to suggest a raised disc or hump. The stems of the moon daisies were a strong dark green. I painted in a wet solution first along the stem, and dropped a stronger mix (less water) into the wet, allowing it to travel along the prepared run to give a natural effect.

Stage 1: plotting diagram. 19¾ × 16 in (50 × 40·5 cm)

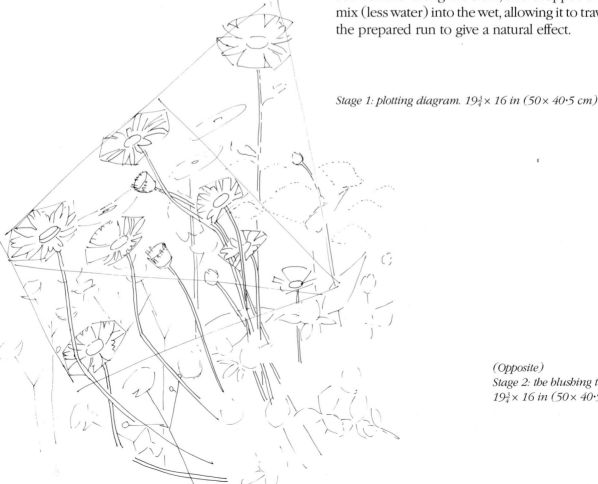

(Opposite)
Stage 2: the blushing technique.
19¾ × 16 in (50 × 40·5 cm)

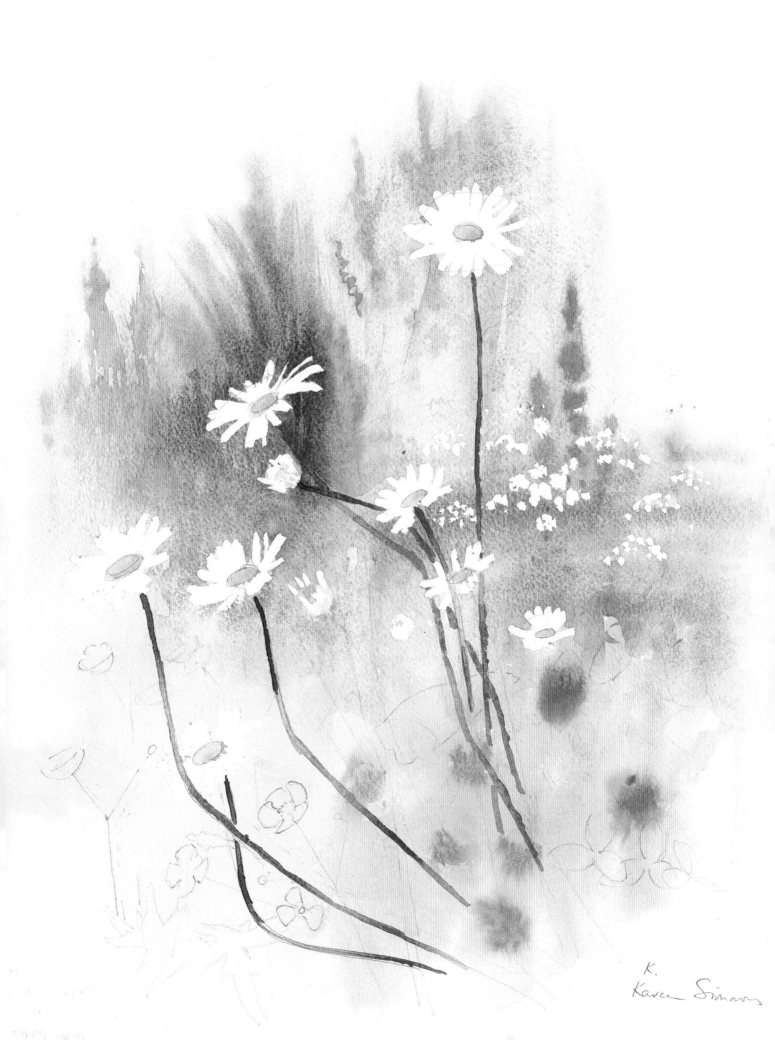

Karen Simmons

Finished painting *Painting into the blush*

Keeping the buttercups dry, I re-wetted the yellow area and dropped in a deeper yellow, tinting it to a yellow-green in places with the addition of a small amount of Cerulean Blue. As soon as this was dry I deepened the shadow petals of the buttercups using Gamboge. In this way, parts of the buttercups were formed from the initial blush. I also painted the stems and leaves of the buttercups with a yellowy-green.

Moving to the clover area, I deepened a few of the flutes with stronger Permanent Rose, then glazed over the pink between the clovers with a thin wash of Cobalt Blue and a little Cadmium Yellow. This green glaze, over the pink, had the effect of greying the area, creating a good colour base for the clover leaves. Darkening behind some of these with more leaves and layering a few on top gave a three-dimensional effect.

A little pink over the blue suggested a few precious orchids. I deepened the blue behind the speedwells and added some more details to the sorrel.

I then wove a few more leaves and grasses through the existing stems. Finally, I shadowed some of the daisy petals, sometimes with blue but also with a warmer yellowy-green. I ignored the fine groove lines on the petals, their whiteness being the greater truth.

It was time to take the painting home and later to assess whether it needed any more tone or details. It helps to look at a painting in a mirror, at any stage of its development. This shows you straight away whether the painting is out of harmony with itself.

(Opposite) Finished painting: painting into the blush.
19¾ × 16 in (50 × 40·5 cm)

(Below) Detail showing layered blushes

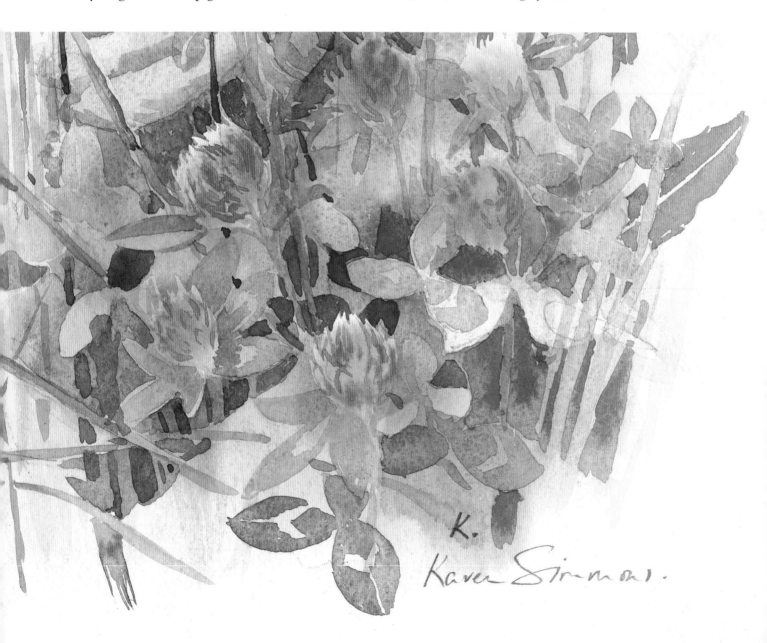

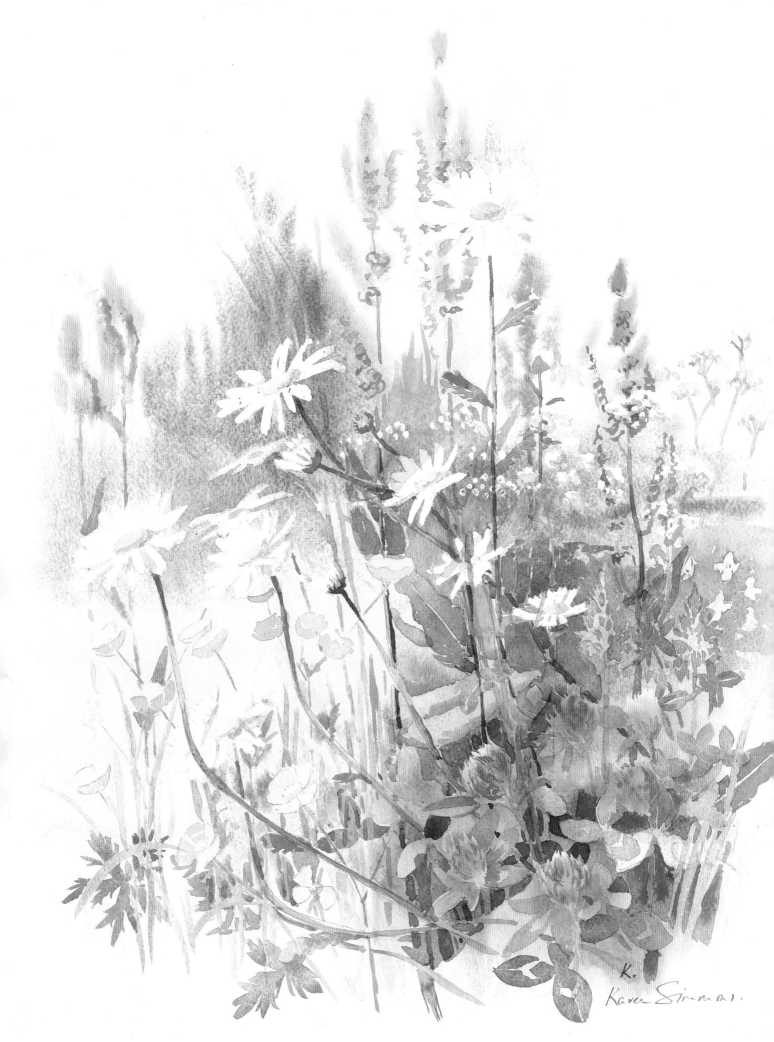

K.
Karen Simmons.

Stage 1: plotting diagram. 16 × 19¾ in (40·5 × 50 cm)

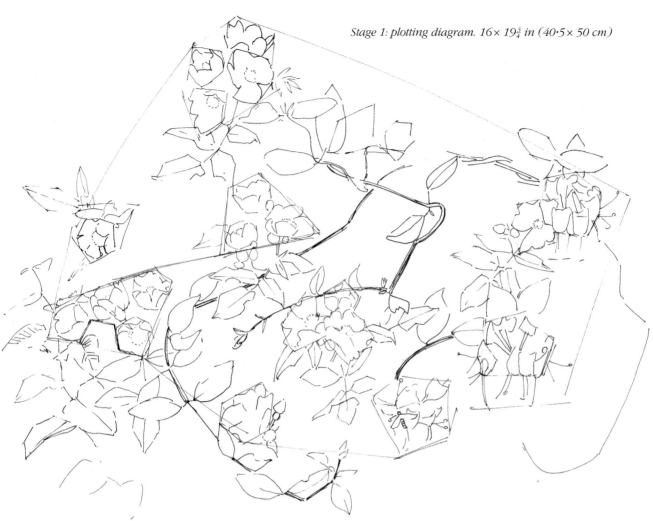

Wild roses and honeysuckle

During the season of wild roses and early honeysuckle I was lucky to find this group, with the added bonus of the young coppery beech leaves enhancing and blending with the apricot pinks of the unfolding roses.

Stage 1 *Plotting diagram*

After a long hard stare, as before, I chose a group threaded with some honeysuckle stems. I made a diagrammatic study of the group, within which I boxed the roses – sometimes in twos and threes. These lines can be drawn very lightly with a soft 4B pencil; later they can be rubbed out or absorbed by the painting. I drew the leaves with respect, noting the joins, angles and space shapes and where they came in relation to the flowerheads (see the diagram on the right of drawing leaves with straight lines before softening into curves).

Stage 2 *Blushing*

I did not use masking fluid this time, but just kept the chosen roses dry and wetted the rest of the paper. I used Aureolin and Gamboge for the honeysuckle area and diluted Permanent Rose for the roses. I added some yellow to the pink for the peachy blush; this was also used to deepen the tone behind the centre whites. In preparation for some of the leaves, I blushed the cooler area with combined Cerulean and Cobalt Blue.

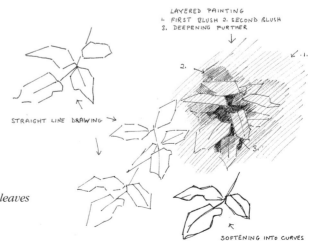

LAYERED PAINTING
1. FIRST BLUSH 2. SECOND BLUSH
3. DEEPENING FURTHER

STRAIGHT LINE DRAWING

SOFTENING INTO CURVES

Stages of drawing leaves

Stage 2: blushing. $16 \times 19\frac{3}{4}$ in ($40 \cdot 5 \times 50$ cm)

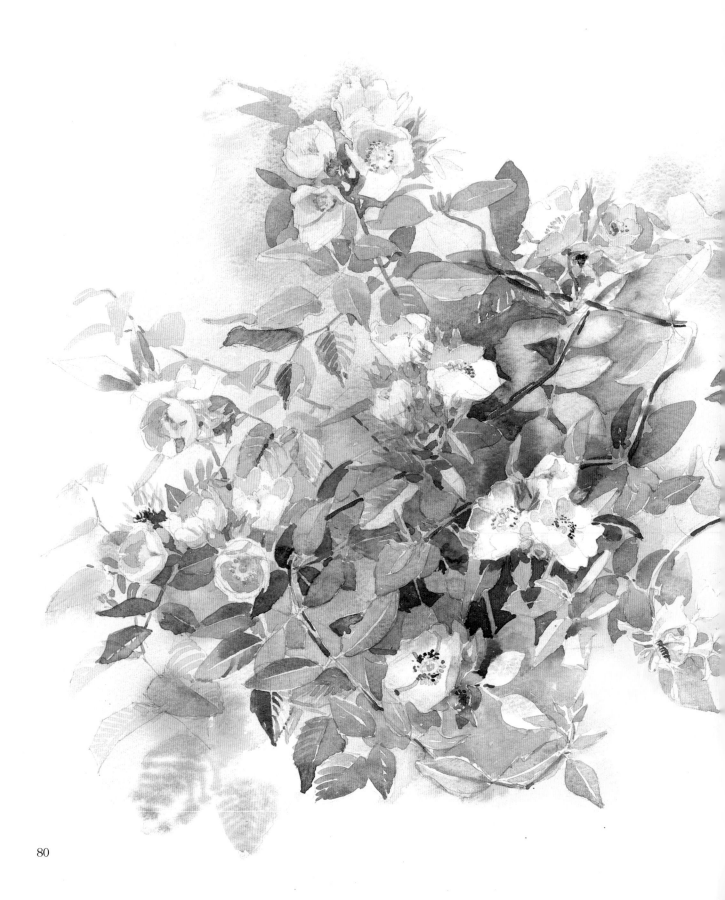

Finished painting *The additional layers*

I added the yellow centres of the roses with rich Gamboge. When all these blushes were dry I sought out the fascinating rhythm of the honeysuckle stems.

It was then necessary to introduce a green blush behind the centre roses. The method I used was to re-wet a generous area, moving the brush in one direction only, before dropping in a cool green within this area. I allowed this pigment to disperse, so avoiding any abrupt, hard lines. The cool green represented the cool downward light, giving a sheen to the top leaves. I painted the deeper, even dark leaves with a warmer green of French Ultramarine and Cadmium Yellow, using less and less water and darkening still further by adding a touch of Cadmium Red. This combination makes a remarkably recessive dark.

I painted the beech leaves with a deeper mixture of Gamboge and Permanent Rose, and when this was dry I added crisp pleats to a selected few. I deepened the colour behind the honeysuckle with a yellowy-green, adding the distinctive shapes of the honeysuckle leaves; this all helped to show up the very pale tubes and trumpets of the honeysuckle. I created shadows on the honeysuckle with mauve over yellow, which became a beautiful transparent grey.

On the white or near-white roses the shadow colour was a dilute Cobalt Blue. In the heart of the pinker roses, Gamboge with a little Permanent Rose gave a glow to the depth. I indicated the tangle inside while still damp, using either Madder Brown or Raw Umber reddened with Permanent Rose.

I painted the peripheral leaves in warm and cold greys without any indication of veins or texture, but with good leaf shapes. Any leaf texture should be confined to the focal area and kept to a minimum.

A little extra background seemed necessary, especially behind the roses at the top left-hand corner. I re-wetted the area here to the edge of the paper, then strengthened the tone using Permanent Rose with just a little of the green on the palette.

The balance of a painting is crucial. Sometimes I add some extra shadowy leaves, restraining myself from doing too much! Being totally absorbed by a tiny patch of nature can be deeply refreshing.

Finished painting: the additional layers. 16 × 19¾ in (40·5 × 50 cm)

Spring weeds

This little tangle was made up of grape hyacinths confused with forget-me-nots, some nettle-like weeds and wild pansies, their heads tilted at enquiring angles. At the base of the group were some dry leaves and a snail's shell.

Starting with very little drawing, I mostly painted directly with colour, adding some over-drawing at the end. First I blushed the blue (Cobalt Blue with a little Cerulean) into the pre-wetted paper. I just touched the tips of the nettles with Permanent Rose.

I painted in some of the grasses and the grass-like leaves of the grape hyacinths before the paper had dried to suggest some out-of-focus effects, and also to prepare the ground for the front leaves. While this area dried I painted the hyacinth flowers with Cerulean Blue and French Ultramarine, treating them as coloured silhouettes. I created the forget-me-nots from the blue blush, occasionally painting in a few heads in a deeper blue and sometimes darkening behind.

The nettle-like weeds were especially attractive with their pink and magenta tips. When mixed with the yellow-green of the heart-shaped leaves these pigments made a very pretty carnelian colour. The stems also showed red. The vibrant purples of the little pansy heads could only be suggested by clashing the colours. I used pure French Ultramarine, pure Permanent Rose, and then mixed Prussian Blue with Permanent Rose to achieve the intense purple. I added the deeper colours while the lighter colours were still damp, rather than wet, to allow the pigment to travel a little before settling.

There was a lovely swirl to the leaves of the hyacinth, so, keeping to this rhythm, I darkened behind some of the interval spaces, seeing these as unexpected shapes.

I wetted between the pansy leaves in the foreground, bringing the wet brush to the edge of the paper and dropping Raw Umber with a little Light Red close to the leaves, letting it disperse unaided. I then darkened again behind the snail and dry leaves before adding some detail to the snail and leaf. I closely observed which leaves were light against dark; which were dark against light; which were cool and which warm. This helped to create a sense of depth in this patch of spring weeds.

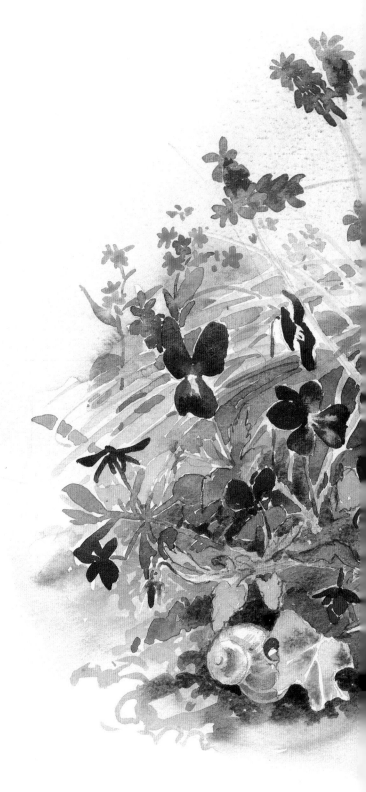

Spring weeds
16 × 19¾ in (40·5 × 50 cm)

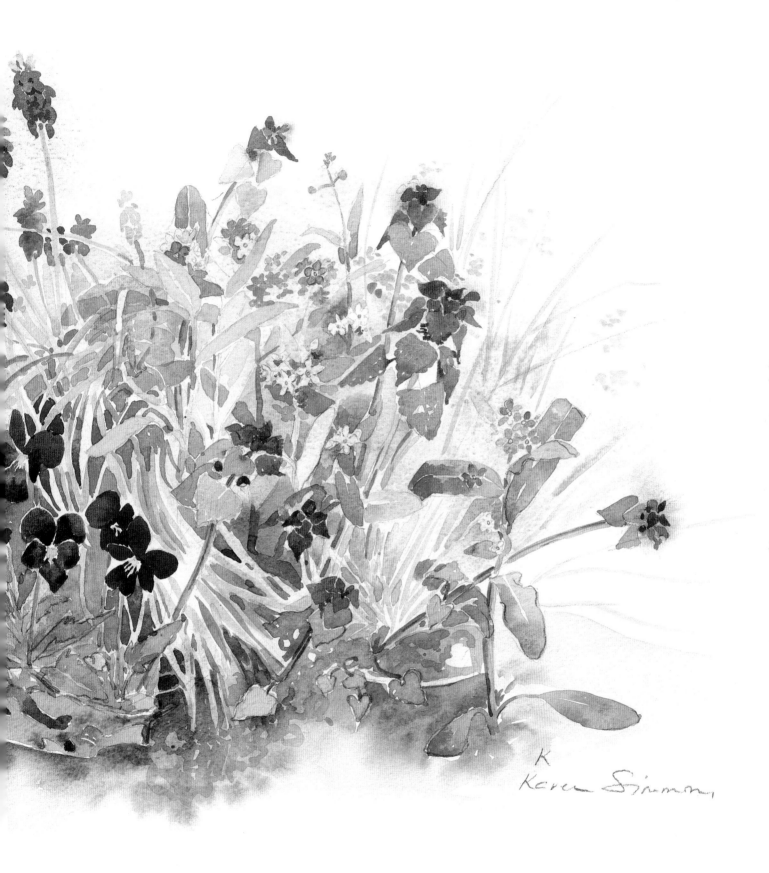

Autumn berries

There is always something worth painting in the hedgerows, especially in spring and autumn. Here the blackberries were beginning to turn and the elder-berries and sloes were attracting the birds, which drew my attention to this little cluster of brambles. First of all I made a light drawing of the thick bramble branch with some leaves and the sprays of fruit, as well as an indication of the fence and the blackthorn tree.

I then wetted the whole paper and blushed a diagonal through the middle with a cold green made

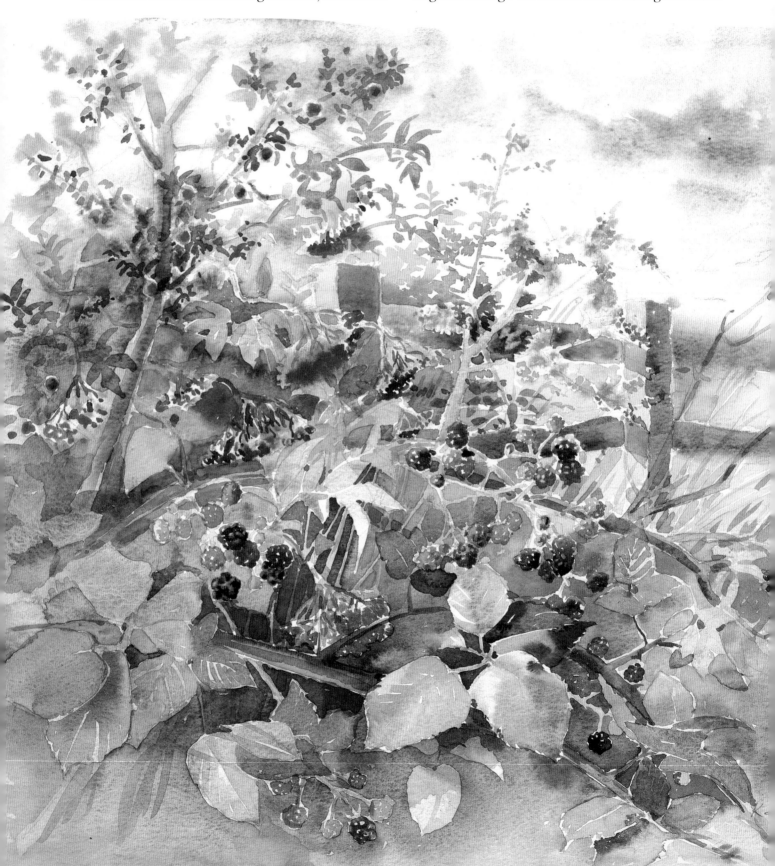

up of Cerulean Blue with a tiny amount of Yellow Ochre. These two colours separate and granulate, suggesting texture. I added more Yellow Ochre below. I blushed in some Cadmium Yellow to the right and allowed it to fuse with the rest.

I used Cobalt Blue for the sky patches between the suggested clouds, which I then shadowed with a little Raw Umber. This had to dry, so I was able to pause and catch my breath!

The thick bramble stem had ridges and facets requiring several different reds, such as pale Permanent Rose, Permanent Rose with Cadmium Yellow, a touch of Magenta and even some Cadmium Red on the junctions. I painted each of the blackberries in turn, keeping some of the sparkle lights on the berries. For the red berries I painted some yellow in first and touched in the red afterwards. For the riper berries I underpainted with Cobalt Blue, then darkened with French Ultramarine and a touch of Cadmium Red.

The elderberries could have been a painting in their own right, they were such a lovely combination of colours. The upside-down view of the claret-coloured stems, heavy with the wine-dark fruits, was appealing. It was, however, necessary to portray them as the supporting cast and not to allow them to take centre stage. I also painted the sloes and other berries, keeping detail to a minimum.

Keeping the cool green blush for some of the leaves, I then painted negatively, deepening and warming the green behind these few leaves. To do this required re-wetting the paper between and behind the chosen leaves, then mixing a deeper green with French Ultramarine and Yellow Ochre and dropping it into the wet area. When this was dry I could repeat the process, darkening again behind some of the grasses.

Returning to the top leaves, I tinted one or two of these with Light Red and Yellow Ochre, suggesting just a few of the veins. This method of painting negatively kept the leaf surface very fresh. I painted the fence a mauvy-grey, mixed from dilute French Ultramarine with Permanent Rose, tempered with Raw Umber.

A subject such as this necessitates leaving a lot out, and selecting through half-closed eyes the essential ingredients for the 'story' of autumn berries.

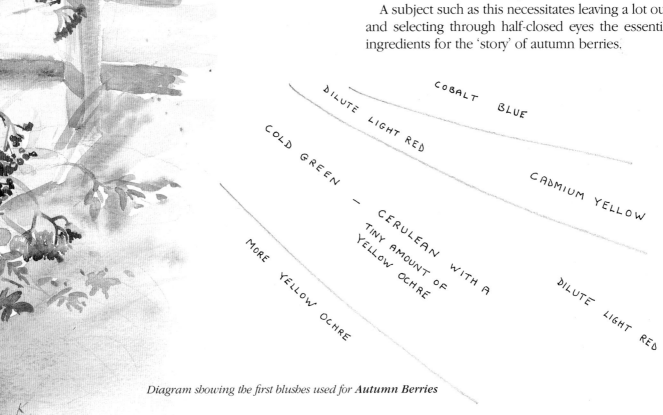

Autumn berries
16 × 19¾ in (40·5 × 50 cm)

Diagram showing the first blushes used for **Autumn Berries**

Camomile daisies

Painting white flowers against an almost white background can provide an interesting challenge. These daisies were growing at the side of a track, seen in blazing Greek sunshine with their patterned shadows clearly printed on the stones below.

I plotted the zig-zag rhythm of the daisy heads and then drew the daisy outlines, noting the occasional gaps between petals. I placed the stones in relation to the daisies and also drew in the stem shapes, carefully observing where and how they connected.

I sat on the hard track, on my dustbin bag, while I worked, suitably protected from the sun with a broad-brimmed hat and a long-sleeved cotton shirt with upturned collar. My legs were covered with my backpack, which supported my drawing-board. The friendly local Greeks were very concerned that I was out in the full May sun, and tried waving me into the shade. Before beginning the painting I placed a thin, wet cloth under my paper to keep it cool, which is always advisable when working in hot weather.

Taking a pointed no. 24 brush, well-loaded with water, I went round the daisies and flooded outwards to all four corners of the page. I used a dilute mixture of Light Red and Cobalt Blue, dropping this into the prepared wet ground around the daisies, varying the mixture. The colour travelled outwards, dispersing back to white before reaching the edge of the paper. This first pale wash became the colour for the sun-bleached stones. When it was dry, I deepened the colour still more between the stones and the daisies.

I used Light Red tempered with a little Cobalt Blue for the rosy shadows cast by the stones. The deeper colour helped to reveal the shapes of the stones. The star-shaped shadows from the daisies on the ground were a red-mauve colour, but on the white stones a strong Cobalt Blue. The addition of these attractive shadow patterns provided a contrast to a few of the daisy petals.

I then placed the bright yellow centres. Where some petals were in shadow I painted in some Cobalt Blue. It only remained to add a little blue-green to suggest the sparse leaves, which I obtained from Cobalt Blue with just a little Cadmium Yellow. Some of the daisies showed up against the shadows, while others were lost against the light ground. I found this effect attractive and therefore left them undefined.

Camomile daisies
16 × 19¾ in (40·5 × 50 cm)

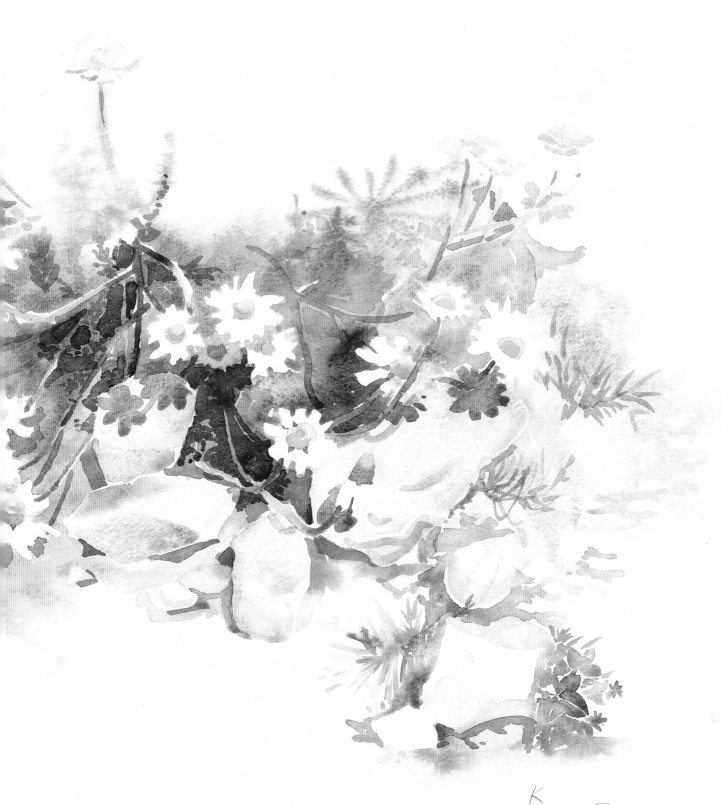

K
Kara Simmons

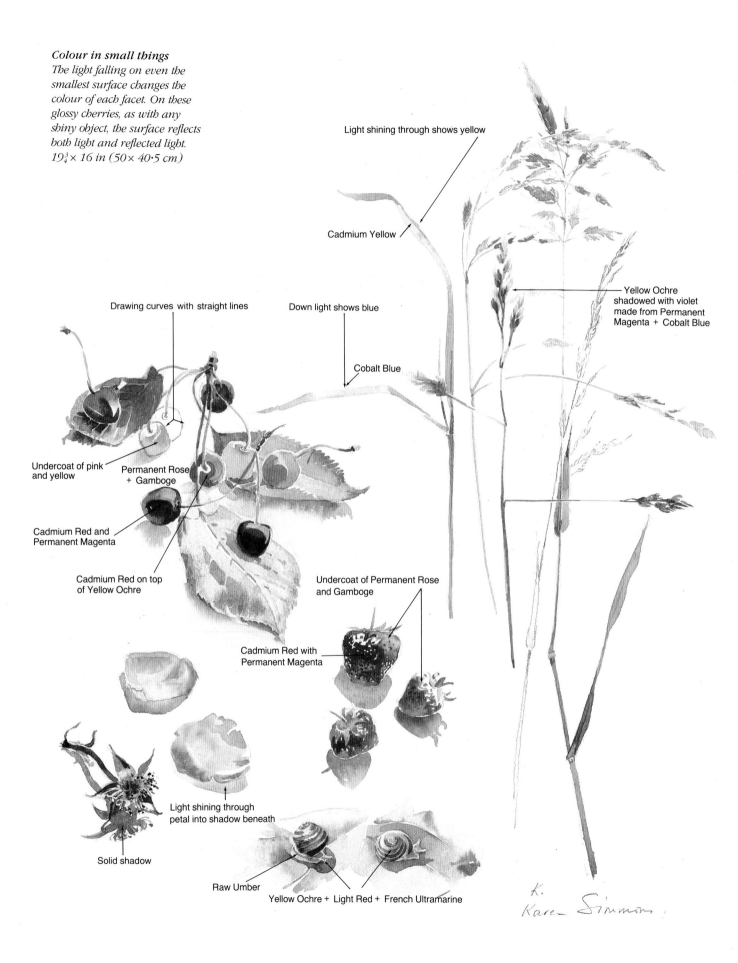

Colour in small things
The light falling on even the
smallest surface changes the
colour of each facet. On these
glossy cherries, as with any
shiny object, the surface reflects
both light and reflected light.
19¾ × 16 in (50 × 40·5 cm)

Light shining through shows yellow

Cadmium Yellow

Yellow Ochre
shadowed with violet
made from Permanent
Magenta + Cobalt Blue

Drawing curves with straight lines

Down light shows blue

Cobalt Blue

Undercoat of pink
and yellow

Permanent Rose
+ Gamboge

Cadmium Red and
Permanent Magenta

Cadmium Red on top
of Yellow Ochre

Undercoat of Permanent Rose
and Gamboge

Cadmium Red with
Permanent Magenta

Light shining through
petal into shadow beneath

Solid shadow

Raw Umber

Yellow Ochre + Light Red + French Ultramarine

K.
Karen Simmons.

Colour in small things

In this group of cherries I have demonstrated the different stages through which I work with this type of detailed subject. My first step was to draw the curved cherry with a series of straight lines to arrive at an accurate curve. I painted the sheen on the cherry with a cold pink (very pale Permanent Rose) and gave the remainder an undercoat of yellow (Gamboge or Cadmium Yellow). When this surface had dried, I painted in Cadmium Red over the yellow. While the red was still damp, however, I added a deeper, darker red where intensity was required. For these cherries I mixed Permanent Magenta with Cadmium Red, keeping the mixture strong by not going back to the water pot.

I described the convex and concave shapes of the cherry leaves with different greens, using a weak solution of Cerulean Blue with just a little Cadmium Yellow and varying the combination. I changed to French Ultramarine and Cadmium Yellow for the deeper shadows.

The glitter on the strawberries comes from the white paper, which I left untouched. The reds varied according to the shape of the strawberry, with the reflected light playing an important part. I showed the pip marks light against dark and dark against light. I coloured the shadows on the ground in relation to the echo from the strawberries.

It was fascinating to see how the light penetrated *through* the rose petals, colouring the gentle shadow below. The spent rose provided an altogether more solid interruption to the light and created a distinct shadow shape.

The leaves on the grasses show how the colour is changed by the light shining *on* the leaf (blue) or through the leaf (yellow to yellow-green). I painted the grasses with Yellow Ochre shadowed with a violet made by mixing Permanent Magenta with a little Cobalt Blue.

Snails are not the slow movers one would imagine. This charming snail, looking like a striped humbug, was no sooner placed on the leaf than it did a three-point turn and headed off. I wanted to convey the fact that its stripes showed most clearly in shadow, and more faintly in the bright light.

Shells and pebbles

I collected these shells and pebbles from a Sussex beach. At home I varnished them with clear nail varnish to maintain the wet look.

I painted the pebbles first. I used Raw Umber and Cerulean Blue for the largest stone; this mixture granulates, giving the effect of a rougher texture. I coloured the stone behind it with Raw Umber and French Ultramarine. I painted most of the remaining pebbles with Light Red, Yellow Ochre and French Ultramarine.

When I came to paint the shells, I found that I was using the same palette, and it dawned on me that this was because the shells were of course camouflaged.

Shells and pebbles
7 × 16 in (17·5 × 40·5 cm)

8

Colour in flowers

Flowers seen at close range can tempt one into adding detail and texture. It helps to suggest volume first and then texture, in that order, so as to preserve the forms of the flowers.

Sunflowers in France

Being face-to-face with head-high sunflowers gave me an opportunity to catch their amazing shapes and colours. The sunflowers stood tall with sculpted leaves. They had furry stems holding up the tilted, twisted faces with ragged flaming petals – some petals missing, some curling inward.

So many painters have been attracted to this tantalizing subject: Emile Nolde with awesome success; Van Gogh with his interacting yellows; most of us with shredded paper and hopes. Capturing sunflowers in paint is not easy!

I plotted the shape of the sunflower nearest to me, noting the shape of the petal gaps and the shape of the face, broader at the base and narrower as it twisted away. Each leaf had two uptilted shoulder shapes in contrast to the flat triangle of the rest of the leaf; this would require different tones and varying greens to describe the change of angle. Where part of the leaf lay flat and sky-related, I used a cooler, paler blue-green. Where the angle was steeper, I mixed a richer, deeper green with a combination of Cadmium Yellow and French Ultramarine in varying proportions and strengths.

I painted the sunflowers with Cadmium Yellow Pale and Cadmium Yellow, trapping some of the pure white of the paper to enhance and dramatize the yellow petals. For the shadowed petals I mixed a reddish-purple from Permanent Rose with a little French Ultramarine, and added the yellow that I had been using into this. The result was a burnt-orange colour. I kept this for just a few petals, leaving most of the petals ungrooved and untouched.

I painted the dark faces with an olive green deepened with Cadmium Red. Once I had painted the main and bowed heads, and added the major leaves and allowed them to dry, I wetted the whole of the remaining space to all four corners of the paper and blushed in some Cadmium Yellow with a touch of Permanent Rose for the evening sky. While this was still wet I painted in the trees, using French Ultramarine with Permanent Rose. This colour exploded in the wet to suggest out-of-focus trees. As the paper dried I silhouetted the French roof and poplar beyond. Finally, coming back to the sunflowers, I suggested one or two more heads and faces.

The frogs from a nearby pond were in full chorus by the time I had finished the painting.

Yellow rose illustrating the use of white with yellow, and yellow with white

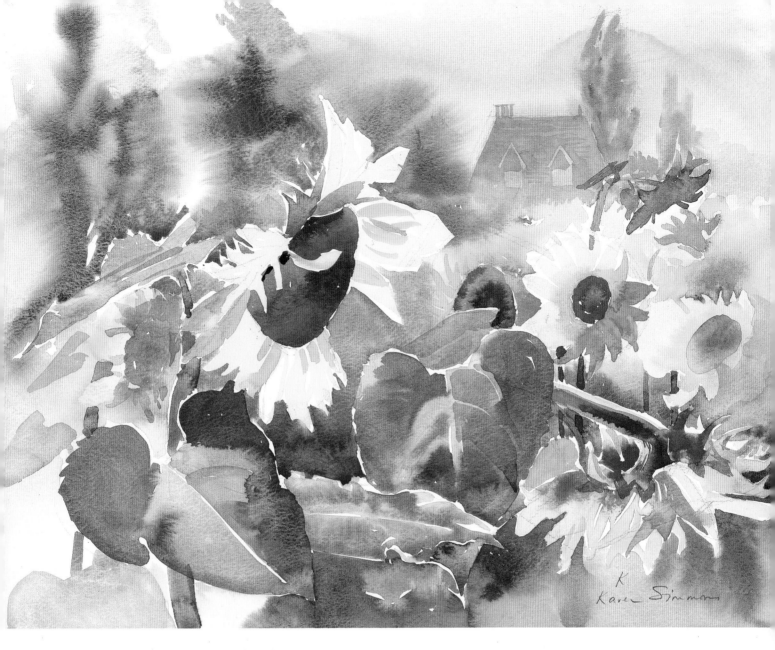

Sunflowers in France
$14 \times 16\frac{1}{4}$ in $(35 \cdot 5 \times 41 \cdot 5$ cm$)$

Zinnias and Michaelmas daisies

While staying in Austria with my sister I gathered these late-summer flowers and placed them into one of her favourite handmade jugs. The wonderful combination of colours sent me in search of my paintbox. I placed the flowers outside in the sun on an old wooden pedestal, and painted straight in with only a few plotting lines to guide me. I deliberately let the flowers expand to the top of the paper, as the subject was explosive – a celebration of colour.

I painted all the yellows, oranges and reds first, concentrating more on the form than on individual petals. The strong light yellows contrasted with the deeper reds, and the sharp pinks were also shadowed with the warmer reds. I painted the papery lanterns, with their thin, crisp facets, with yellows and reds.

At this stage I wetted the rest of the paper and blushed in the pale mauvy colour ready for the Michaelmas daisies. The blush comprised Cobalt Blue with Permanent Rose, deepening to French Ultramarine and Permanent Rose. On the left-hand side I used a blush of Cadmium Yellow Pale with Yellow Ochre.

When painting the individual Michaelmas daisies, I omitted the lower half of each daisy face from the initial blush. I deepened the shadowed part with Cobalt Blue reddened with Permanent Rose. I ignored the groove marks, and suggested the petal shapes selectively. In some cases I deepened the colour behind to show up the lighter profiles. I painted some of the leaves into the wet, and others when the surface was dry, keeping to a blue-grey in the Michaelmas daisy area and a richer, warmer green for the berries and zinnias.

I then painted the jug, with its bright splash of blue decoration, with vivid, clashing blues. I coloured the shadows cast on the wall behind with a soft grey made with orange and blue. These were complementary colours present in the subject, and therefore maintained the colour harmony.

I painted the seasoned wooden pedestal with Raw Umber, shadowed and tempered with mauve. The deeper shadows cast by the pot were more blue, due to the reflected colour. I painted the shadow shape cast by the stem and the zinnia head with mauve over the Raw Umber.

The bright zinnia head against the blue pot had been irresistible as a subject. Sadly, a freakish gust of wind suddenly toppled the whole lot over and the favourite blue jug was smashed. In atonement I gave the painting to my sister.

Zinnias and Michaelmas daisies
16 × 19¾ in (40·5 × 50 cm)

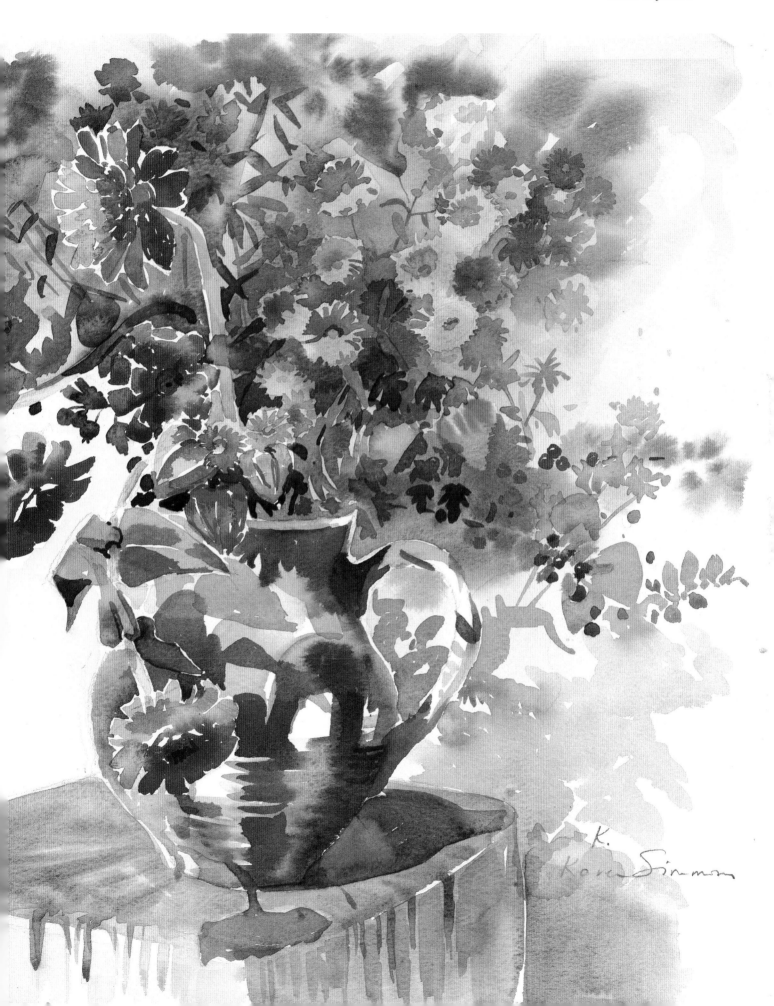

Bougainvillaea

Instead of painting these dramatic leaves in the bright sun of the Mediterranean, America or Australia, I painted them in a greenhouse in England with the natural light coming through glass. The door, dappled with shadow, opened on to a patch of sun behind. The sprays of bougainvillaea crossing in front of it made for a very colourful subject. The crisp papery shapes, with the tiny white flowers inside, were fascinating to study.

The colour was so vivid that only pure pigment would do. Where the leaves were lit by the downward light I used pure Permanent Rose, sometimes diluted, and at other times full-strength. Occasionally I dramatized the colour by adding Permanent Magenta.

Where the light penetrated through the leaves to those below I used Cadmium Red. This provided the shadow colour as well as the clashing colour, making the combination more vibrant.

A further clash was happily provided by the sunny patch behind the central spray. I wetted carefully around the sprays which crossed the opening space between the door and the wall, and dropped in some Cadmium Yellow. I dappled this at the bottom with some Cobalt Blue, but at the top with the deeper and heavier French Ultramarine and Yellow Ochre.

Detail of the painting opposite, showing the relationship of colours

Keeping only part of the door pure white and dry, I wetted the rest, waited for the shine to go, and then, using Permanent Rose and Cobalt Blue, painted in the soft shadows. When this was dry I further defined the edges to the woodwork.

For the glass, I wetted the panels first and then added a soft mixture of French Ultramarine and Yellow Ochre, with just the faintest touch of yellow and pink in the corner of the glass to suggest the reflection of the tip of the vivid pink spray. I painted the green leaves, observing closely their distinct shapes and the downward-light sheen on some of the facets. I used a combination of French Ultramarine with Yellow Ochre, adding in a touch of the Permanent Rose when I needed to grey the leaves further. I painted in the stems and stalks at intervals.

For the background wall, behind the leaves on the left-hand side, I used a mauvy-blue, toning in with the leaves in places. This kept the area supportive and quiet.

I completed the painting over the span of several days, as I was only able to get to it for part of each day. Frustrating though this may have been at the time, the benefit was that I came back to it each time with a fresh and critical eye.

(Opposite) ***Bougainvillaea*** *19¾ × 16 in (50 × 40·5 cm)*

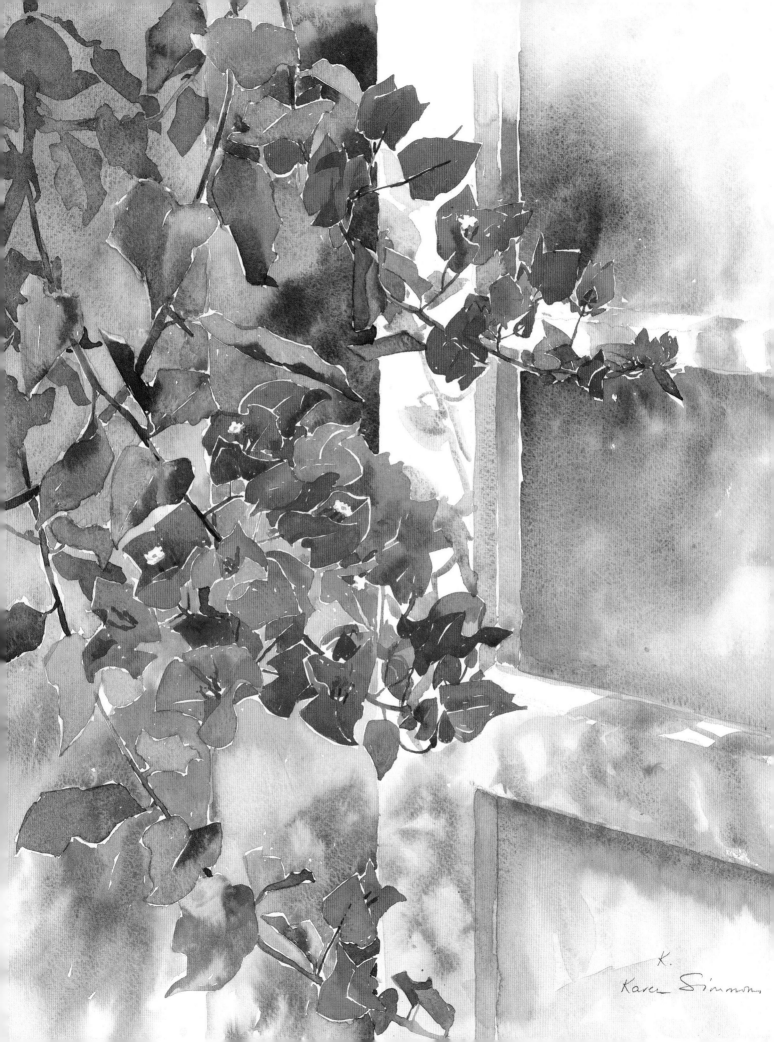

Karen Simmons

Hollyhocks (*opposite*)

This group of hollyhocks stood tall in the corner of a flowerbed, the flowers interchanging light and shadow amongst themselves as if gossiping, their heads turning in all directions.

I made no attempt to paint the whole stem as this would have reduced the scale of the flowerheads. It was the flowerheads that had attracted me, so I concentrated on these, contenting myself by painting the tips of distant hollyhocks into the background.

To show the strong tonal difference between light and dark caused by the bright sunshine, I kept the light areas very light – almost white in places – so that the richer pinks had plenty of contrast.

The first stage was to paint in an extra-pale diluted Permanent Rose, leaving a few pure white patches. There was a hint of golden pink at the base of the open flowers; for this I used Gamboge, letting it mix with the Permanent Rose on the damp paper. I added the stronger pinks when this first stage was dry, and took care to show how the shadows were shaped by the fluted petals. The groove marks were sacrificed in the light and only shown in the shadow areas, and I used Cadmium Red for these. A colour clash to show a dark seems to work better for flowers; using greys or blues to shadow or groove a flower can build a rather drab effect. Stems and bud intervals must be carefully respected: if the stems are straight and sturdy, so be it.

Before painting the leaves, I wetted around the flowers to all four corners of the paper and prepared blush colours for the appropriate areas. This background blush can be preserved for some of the leaves or parts of a leaf, with a deeper or different colour painted sometimes behind and sometimes on top of it. This method can helpfully suggest layers of leaves without looking too 'worked'.

Lastly, I selected just one or two leaves to show any veins or details. The quieter I kept the leaves, the more the flowers could show off their beauty.

In conclusion, when painting flowers you must respect their design: the stem shapes and intervals, the shapes of the leaves, and the proportions in the flowerheads. Show the tonal contrasts which describe the form *with* colour, and you will capture their fragile, sculpted shapes.

Primulas and tulips
I used cold pink shadowed with warm red for these flowers. 10½ × 19½ in (27 × 49·5 cm)

Hollybocks
$19\frac{3}{4} \times 16$ *in* $(50 \times 40 \cdot 5$ *cm*$)$

K.
Karen Simmons

9

Colour in the seasons

Each season has its own special light and colour, merging into the next as the year moves on. One can be alert to this change: something in the air and light brings the response that 'spring is on its way'. Similarly, on a day later in the year, perhaps early in the morning, you may sniff the air and say 'autumn is coming'.

The colours in the countryside change from the fresh, vibrant greens of spring to the more uniform, mature greens of summer. Moving on into autumn, certain trees are highlighted with colour, bringing them into prominence for the first time. Then winter comes, and the light is either bright or filtered. The sun, low in the sky, also reveals colours and shapes not seen before.

The same subject painted at different seasons – even at different times of the day – will present many changes in colour and tone.

Catkin time, spring

This was a brilliant February morning, fresh rather than cold, and the sky a wonderful washed blue; the perfect day to take one's paintbrushes out of doors again. The barn, seen through the thick tracery of saplings, twigs and catkins, was reflected in the pond with the deep blue of the overhead sky. The scene was framed by the twigs like a leaded stained-glass window.

I had to consider carefully how to tackle a subject like this, in which the complex foreground was paler than the richer colours beyond.

First, I needed to draw the foreground saplings with care, noting how and at what angles the branches stretched from the slim trunks. I also noted the space shapes created by the cross-threading of the twigs, through which the barn and pond could be seen.

I used Cadmium Yellow Pale for the catkins and some of the grasses. With the addition of Raw Umber this became a lime green, which suited some of the saplings. I was also able to suggest the shadowed twigs by deepening the colour with more Raw Umber.

A few of the young trees were a cooler grey, and for these I mixed Cobalt Blue and Permanent Rose with only a tiny amount of Cadmium Yellow Pale to make a mauvy-grey, and Cobalt Blue almost on its own for the silvery-blue. Where the twigs thickened into brush-wood I wetted the area, added dilute Raw Umber into this damp patch and then blurred in some more twigs. I enjoyed watching out for the lighter branches and twigs as they crossed the darker ones. The ivy-covered trunks provided a good tonal contrast.

All this had required some fierce concentration, so a break and a cup of coffee seemed a good idea. I also got up to stretch my legs. This made the farm dog bark again, and a figure emerged to see what I had been doing sitting in the ditch for so long.

With clean water and a cleaned mixing palette I started on the colourful view between and beyond the trees. I had to work this in and around the light catkins and twigs. A brush with a good point, well-loaded and wet (but not too wet) gave me good control. I painted the bright roof with Light Red and Yellow Ochre.

I obtained the warm, purply colour with French Ultramarine, Permanent Rose and a touch of Light Red. The reflection of the barn needed the same colour combination, with the shadowed wall showing an even more dramatic colour in the water.

The lovely fresh blue sky was paler on the horizon and around the barn, but a much deeper blue in the pond. For the paler colour a combination of Cerulean and Cobalt Blue seemed right, deepening to Cobalt Blue with the faintest hint of Permanent Rose towards

Catkin time, spring
16 × 19¾ in (40·5 × 50 cm)

the top of the painting. For the upside-down sky reflected in the water I used French Ultramarine modified with a touch of Permanent Rose. The addition of Permanent Rose takes the brashness out of the pure French Ultramarine, giving the blue a greater depth of tone without losing any luminosity. I also worked this round the trees, grasses and brambles of the foreground. The final step was to introduce the far bank and the bank's reflections, the distant trees and the hedges.

Why on earth had I chosen to paint such a taxing subject? The bright day, the dancing catkins and the deep, rich colours beyond were answer enough.

(Overleaf) Detail of the above painting showing foreground contrasts

Karen Simmons

The vicarage in summer

It was the vicarage, in shadow but glowing with reflected light, that drew me to this subject. The churchyard was higher than the road, and so bright with sun that it lit up the brick walls of the vicarage. The little cherry tree cast dappled shadows across the grass and on to the adjacent peaceful tombstones. The midday air was filled with the soft buzzing noises of bees and insects.

Once I had drawn in the composition and used a white grease crayon for the railings, I wetted the whole paper. I blushed in some Light Red across the middle of the painting, followed by some Cobalt Blue above.

I washed in a bright blush for the foreground area with Cadmium Yellow Pale, and also used this colour to prepare some of the cherry-tree area. The aggressive yellow pushed back the Cobalt Blue and Light Red and settled in its place.

When this wash had dried I continued to paint the tree. The light falling through the leaves, as seen from my angle beneath, was warm, ranging from yellow to yellow-green. On the shadowed side, the greens at the top were cooler, for which I used French Ultramarine with very little Cadmium Yellow. The lower, dark leaves silhouetted against the cottage behind were a rich olive green. The trunk was also olive green, and for this I used Raw Umber mixed with Cadmium Yellow Pale. When diluted, this colour is a very lively lime green. Used in greater concentration, with just a touch of additional Cadmium Red, it is a rich olive green.

My next step was to paint the vicarage – already tinted with Light Red from the first wash – with a stronger colour. I used Yellow Ochre and Light Red, tempered in places with French Ultramarine to which I had added a trace of Permanent Rose. I also used this mauvy-blue for the slate roof.

The window panes reflected back a variety of colours. The white woodwork was not pure white, but was also washed with reflected colours which had to be captured.

I added the soft, dappled shadows into the grass below the tree while the yellow was still wet. When I came to put the shadows on to the tombstones I re-wetted some of the area, then painted in the shadows (some crisp, some soft), using Cerulean Blue mixed with Permanent Rose. This violet was subdued as it overlaid the umber and yellow of the stone itself. I shadowed the side of the near white tombstone in the foreground with blue, and the two at the back with a rich olive-and-red mixture.

The vicarage in summer
14 × 17¾ in (35·5 × 45 cm)

Bethel community chapel

I painted this white-clapboard Texan chapel in the summer. It was built in the late nineteenth century and is still in use, although it is now flanked by a newer church built to cater for the growing community.

It was a hot, late afternoon when I saw this view across the duckpond. The sky was a blazing blue, the spire a crisp white reflected in the pond. The huge sweet green ashes crowded, sheltered and shaded the chapel, splattering blue shadows across the white slats. The light was so bright and the colours so clear – a real contrast to the softer colours in England.

I was intrigued by the crane, holding his long neck up and echoing the straight reeds and the white spire. I watched him stalk around the pond with immense dignity, suddenly arrowing in on his catch with darting swiftness. Later the crane went to roost high up in the branches of the willows on the right, the ducks respectfully moving aside as he advanced.

Bethel community chapel
14 × 17¾ in (35·5 × 45 cm)

Detail of shadows

Karen Simmons.

The old bridge

This was a very quick summer painting with no pencil drawing. Before beginning, however, I 'saw' where I wanted to place the bridge.

First of all, I painted the foreground jumble of nettles, sorrel, balsam and other weeds, with the late sun caught and trapped amongst the many leaves. Using the cooler Cerulean Blue to contrast with Cadmium Yellow for some of the leaves I then added Light Red for the sorrel, the colours bleeding rather freely together. The violet-pink of the balsam made a happy contrast with all the yellows in the picture, each enhancing the other. I painted the bridge once the foreground had dried, so that I could cut out the taller nettles.

I painted the brickwork in shadow with a wash of Light Red, Permanent Rose and Cobalt Blue. When this was dry, I over-printed it with the brick pattern.

The sky was a pale orange, and I used a well-diluted mixture of Gamboge and Light Red for this glowing colour. More Gamboge and Light Red became the foundation for the big tree on the left, and I superimposed a stronger mixture of French Ultramarine and Gamboge while this was still wet.

The underside of the arch glowed with reflected light from the sunny banks. The still, rather stagnate water, reflected the shadowed bridge with a deep olive green, which again provided a strong contrast to the foreground.

Each season has colour if you look for it – even on the dreariest of winter days – but the colours of autumn are the most dramatic. Trees almost unnoticed suddenly become a flame of yellow and gold, catching your eye and giving you joy. The leaves of the maple, sycamore and some creepers turn into vivid colours, each leaf becoming a unique miracle. The berries and nuts join in the riot, some lasting well into the winter and making a welcome accent amongst the brushwood and greys of the landscape. In the shortening days the sun is low in the sky and casts a warm, even, rosy light over everything, enhancing the golden colours.

(*Opposite*) **The old bridge**
19¾ × 16 in (50 × 40·5 cm)

(*Right*) *Detail showing counterchange: light against dark and dark against light*

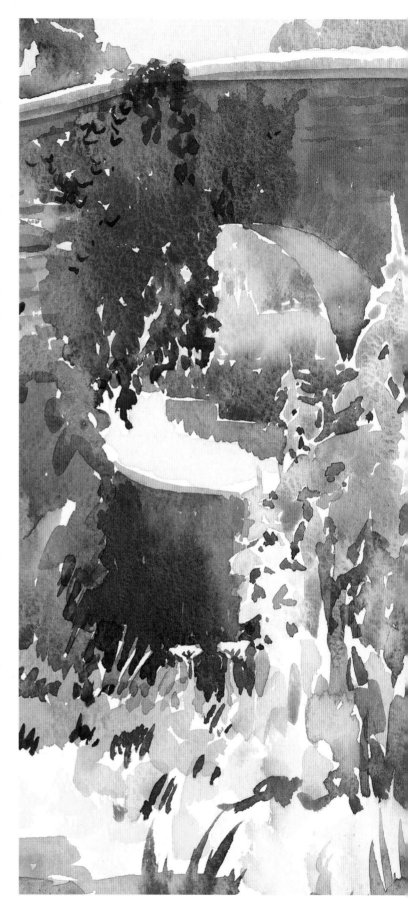

Gold and silver birch

This tree in its autumn colours caught my eye and enticed me into a quick paint. The sun was already fairly low and was going to set quickly, and it was also getting cold.

I carried out a quick plotting drawing to establish the composition, taking careful note of the sky shape; this helped to keep the distant trees in proportion. Continuing with a 6B pencil, I drew the Scots Pine, taking care over the main branch shapes and spaces. I also drew the silver-birch trunk and indicated the simple silhouette shapes of the distant trees.

Preserving the silver-birch trunk by keeping it dry (I could have used masking fluid instead) I wetted the entire paper. While it was still shiny, I dropped in some Light Red in a broad band through the middle, almost to the foreground, then quickly added some Cerulean Blue above, letting it drain gently down. When the shine had gone but the paper was still damp, I added some more Cadmium Yellow to the silver birch along with a touch or two of Permanent Rose. An exciting characteristic of all the yellows is that they are very aggressive, enabling you to add them to a deeper colour while it is still damp; the yellow will shoulder the deeper colour aside.

Still hurrying, I added some of the greens to the big pines, wanting them to fuse with the sky to give an out-of-focus impression. This mixture consisted largely of Yellow Ochre and French Ultramarine, with tints of Light Red where the low sun caught the underside of the foliage. I dropped in some Yellow Ochre and Light

Red at the base of the trees to form the foundation for the bracken. As the paper was drying by this time, I added the blues for the distant brushwood on either side of the main trunks, cutting them out of the foundation blush. I added Gamboge and Light Red to the upper sunlit branches; Yellow Ochre and French Ultramarine to the shadowed lower trunk. I then deepened the colour behind the bracken using Light Red with Permanent Rose, cutting out the bracken shapes.

A little care and patience with a few details satisfies the eye, and the rest can then be suggested. I painted the distant trees as simple silhouette shapes, using Light Red and Cobalt Blue. I shadowed the middle-distant trees with French Ultramarine and Yellow Ochre. I also put in some additional touches to the main pines to suggest the grouping of the branches.

Mixing a large puddle of Cadmium Yellow, I flooded it across the foreground, leaving one or two dry intervals. I added the shadow colours according to the surface on which the shadows fell: a deeper blue-green on the grassy area; a purply shadow across the leaf-strewn path; and the distant shadows losing both colour and tone.

Lastly, I added just a touch more dark to the bases of the pine and silver birch. Having to work fast before the sun disappeared kept me to the essentials and stopped me from adding too many textural details, the glow from the silver birch being the 'story' of the painting.

Detail showing shadow colours changing according to the surface

(Opposite) **Gold and silver birch**
$19\frac{3}{4} \times 16$ in ($50 \times 40 \cdot 5$ cm)

Karen Simmon.

Cinderella

I call this next painting *Cinderella* because the autumn colouring has decked this little wild cherry in full golden dress. Suddenly you notice it in the grey mist among the other grey-green trees.

This subject was going to be a challenge, and I needed to think out my tactics. The cherry tree would have to be painted first. I plotted the relevant heights of the trees and the distances between the bases. With dry paper and a fat brush with a good point well-loaded with Cadmium Yellow, I painted the tree, giving it its leaf profile and noting the shapes of the spaces.

The grouping of the foliage and the spaces was a very important indication of the tree's identity. While the yellow was wet I quickly deepened here and there with Gamboge and Light Red, with just a touch of light green on the lower branches. The slender trunk looked almost black, but I painted it with a red dark: this could be Burnt Sienna or Brown Madder.

Once Cinderella was dry, I wetted the rest of the paper to the edges, going carefully in and out of the leaf shapes and dropping in a soft, slightly mauvy-grey behind the yellow tree with minor variations. For this I mixed Cobalt Blue with Light Red, adding a very small amount of Permanent Rose. I let this travel outwards to nothing in the wet.

As soon as the shine had gone, but while the paper was still damp, I painted in the right-hand pine tree, using different strengths of French Ultramarine, Yellow Ochre and a little Cadmium Yellow. By the time I tackled the left-hand tree the paper was dry, so the profile had more definition; as I was painting I took note of the inner shapes, known as 'sky holes'.

The trunk on the left looked very dark. For this I used Raw Umber with French Ultramarine, first as a weak solution and then as a stronger solution, adding this in here and there where a deeper tone was needed. I painted the misty branches behind in a similar way, first with a wet brush and a weak colour, adding the stronger tone where it would flow along the prepared wet path.

Re-wetting behind the right-hand pine, using a mixture of Cobalt Blue and Light Red to make a blue-grey, I painted another pine slightly out of focus. This trapped some light on the tree in front, giving it a very wet, misty look. I re-wetted the foreground, adding the yellow of the fallen leaves and allowing it to fade into the blue-green areas. This procedure may sound complicated and certainly needs practice, but it does give some lovely in- and out-of-focus effects.

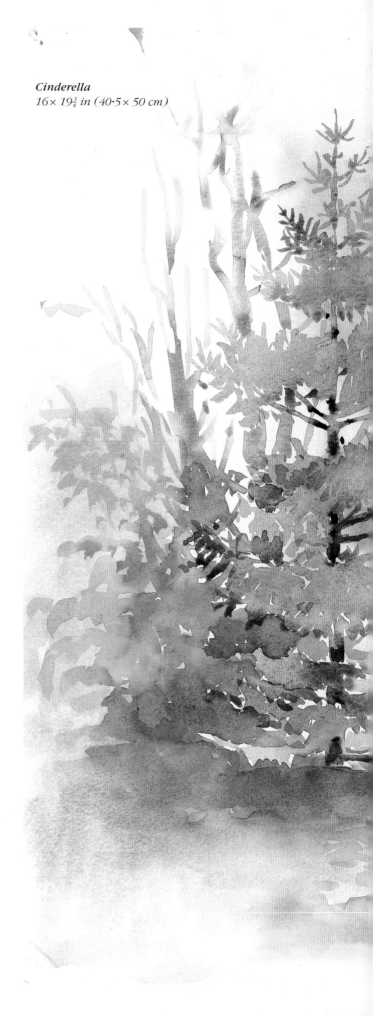

Cinderella
$16 \times 19\frac{3}{4}$ in ($40 \cdot 5 \times 50$ cm)

K.
Karen Simmons
Cinderella,

Maple leaves

I was driving along a lane when suddenly, out of the corner of my eye, I saw this branch of maple leaves back-lit by the sun with the rest of the trees in shadow. Needless to say, the tree was on a blind bend, so, parking the car further on, I walked back to it. The luminosity of the colour just took my breath away. There was no way that I could paint the branch in that position, so I cut it off and took it home!

Once there, I took an earth-filled flowerpot with drainage holes and put it outside on a garden table. I stuck the branch into a drainage hole at an angle and was able to position it against the sun again.

Giving each leaf the full treatment of veins, texture and colour can make a painting such as this monotonous and also less luminous. By choosing one or two leaves as your 'prima ballerinas', and painting them in focus and with some texture, the others can then be treated more and more simply, keeping their true, delicate shapes but ignoring the veins.

I took some care over the way in which the scarlet stems joined at the twig in clusters, and the way in which the leaves were supported. I box-diagrammed the leaves very lightly and then drew in the invasion shapes (see the diagram below). This method helps to keep the proportion and perspective of the leaves at different angles. The diagram lines can then be rubbed out.

Where the light fell on a leaf, or part of a leaf, I saw a cool, light pink, so I used pure Permanent Rose, well-diluted. I then added in Cadmium Yellow to indicate the sun shining through the leaf; it was essential to capture the bright red using this yellow undercoat. I added the touches of green very selectively – too much and the leaves would not glow. I painted the less-detailed leaves simply with Cadmium Yellow and Permanent Rose.

I painted the twig with Cerulean Blue and Permanent Rose, making a violet, tempered with a tiny amount of yellow. I then worked on the background by wetting the paper neatly up to the edge of each leaf and flooding back to the edge of the paper. Next, I dropped in a weak Cadmium Yellow.

To the left of the painting I suggested a few grey, out-of-focus brambles. When all was dry, I painted in a few more brambles, using warm and cold greys, Burnt Umber and Burnt Umber with French Ultramarine. It was impossible to capture the glow of those leaves perfectly, but it was fun to try.

(Opposite) **Maple leaves**
19¾ × 16 in (50 × 40·5 cm)

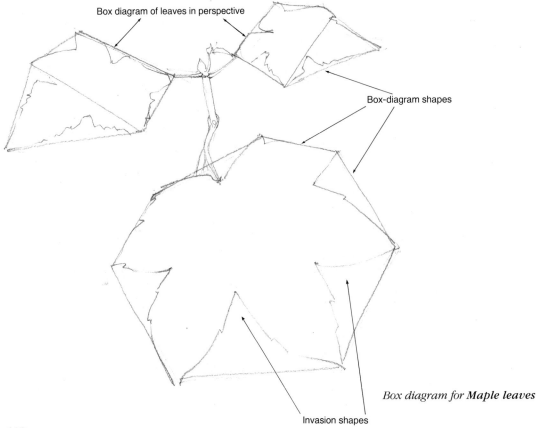

Box diagram of leaves in perspective

Box-diagram shapes

Box diagram for **Maple leaves**

Invasion shapes

K.
Karen Simmon

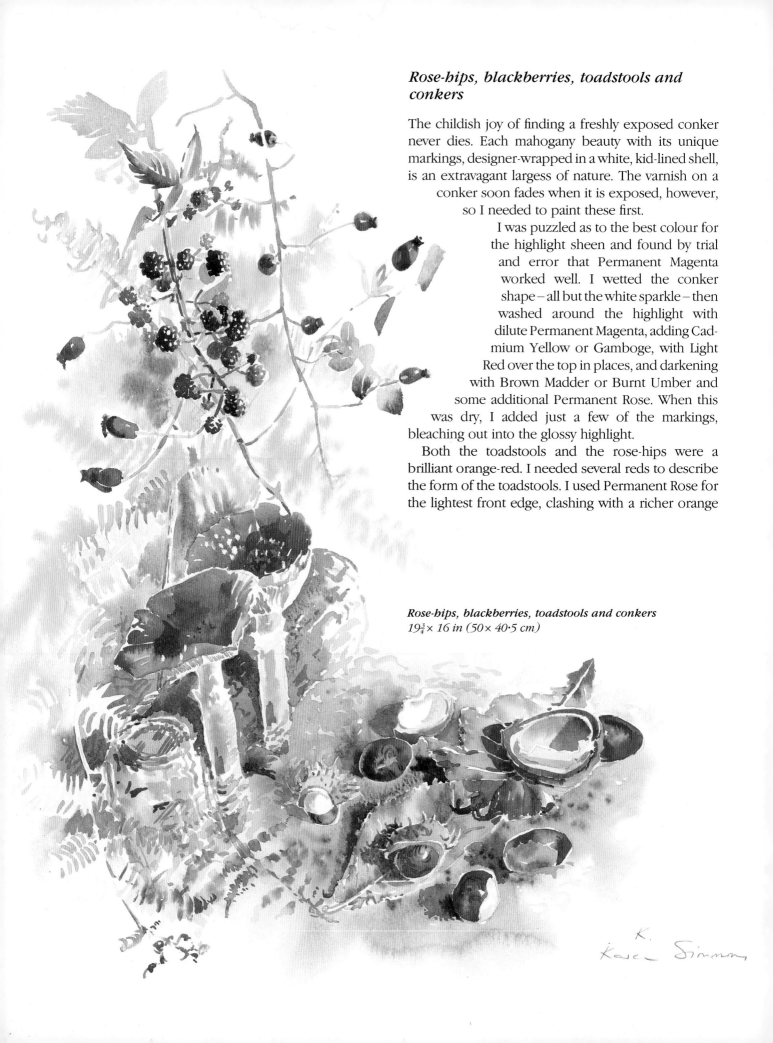

Rose-hips, blackberries, toadstools and conkers

The childish joy of finding a freshly exposed conker never dies. Each mahogany beauty with its unique markings, designer-wrapped in a white, kid-lined shell, is an extravagant largess of nature. The varnish on a conker soon fades when it is exposed, however, so I needed to paint these first.

I was puzzled as to the best colour for the highlight sheen and found by trial and error that Permanent Magenta worked well. I wetted the conker shape – all but the white sparkle – then washed around the highlight with dilute Permanent Magenta, adding Cadmium Yellow or Gamboge, with Light Red over the top in places, and darkening with Brown Madder or Burnt Umber and some additional Permanent Rose. When this was dry, I added just a few of the markings, bleaching out into the glossy highlight.

Both the toadstools and the rose-hips were a brilliant orange-red. I needed several reds to describe the form of the toadstools. I used Permanent Rose for the lightest front edge, clashing with a richer orange

Rose-hips, blackberries, toadstools and conkers
19¾ × 16 in (50 × 40·5 cm)

and yellow, then added deeper red for the shadow over the top. For this I mixed Permanent Rose and Cadmium Red together to make a rich, ruby red.

For the rose-hips I undercoated with yellow, preserving a little highlight. I then bled in the stronger Cadmium Red. Cadmium Red on its own dries to a disappointing red on white paper, as the paper shows through. To get a really glowing Vermilion Red, first undercoat with yellow, and then add the red – it really works!

Between the suggested bracken by the log I used violet made with Cerulean Blue and Permanent Rose modified with a little yellow. I occasionally added a little French Ultramarine to this mixture. This soft violet-grey made a lovely foil to all the yellows.

I painted the blackberries by looping round each highlight with a wet brush. I dropped in some grey-blue, mauve or red, deepening up the colour and losing the highlights on the shadowed side.

Detail showing how colour can build up form

The frozen pond

Winter fog is not a subject with obvious appeal, but for the keen observer it makes a fascinating study. The subtleties between one tone and the next are so fine, yet the shapes are clear. Only as visibility is totally engulfed by the fog is the definition lost. There is colour to be found not only in the foreground, but also in all the greys with which one builds the fine-tuned tones. With Payne's Gray you would be able to achieve all the subtle tones, but you would miss out on the lovely pearly pink-greys, blue-greys, warm greys and many other colours which make fog so magical.

For this subject I timed my arrival to mid-morning, with the thought that the fog would be thinning soon. I had been to this spot before and was curious to see how it would look on this particular day. I should add that I painted this picture while I was inside my car!

Having drawn the trees and major branches with some care, I wetted the paper, all but the pond, which was the lightest part. I then prepared two large puddles of paint: one of Cadmium Yellow Pale with just a tiny amount of Yellow Ochre; the other a violet, this time made with Cobalt Blue and Permanent Rose. First I washed in the dilute yellow, and then flooded in the dilute violet, tempered with a little of the yellow, above the yellow and allowed it to drain down.

With all this washing and flooding, my paper was now very wet, and I needed to wait until the shine had gone. Then, with a stronger mix of the same violet and yellow, I painted in some of the out-of-focus branches and brushwood (this mixture gives warm and cold greys as the amount of yellow is varied). Using the coolest mixture – almost pure Cobalt Blue – I hinted at some very distant trees. By now the paper was dry, and I could paint the more precise shapes of trunks and branches, going in with a weaker value and then strengthening the tone where it was needed.

The ivy became part of the overall silhouette. I painted the distant bank very gently with hardly any texture. For the nearer bank, where the trees, bushes and grasses all shared the same tone, I used a grey made with Cobalt Blue and Light Red. Then, making a cold turquoise-green with Cerulean Blue and very little Yellow Ochre, I washed in the left bank and the foreground. Later, I added a little texture for the grass.

Even on this frosty day, some of the dry grasses were quite blond. I used a touch of Yellow Ochre for these, which linked the warm areas of the painting. It just remained to study the reflections in the near-frozen pond and, with great restraint, I mirrored the bank.

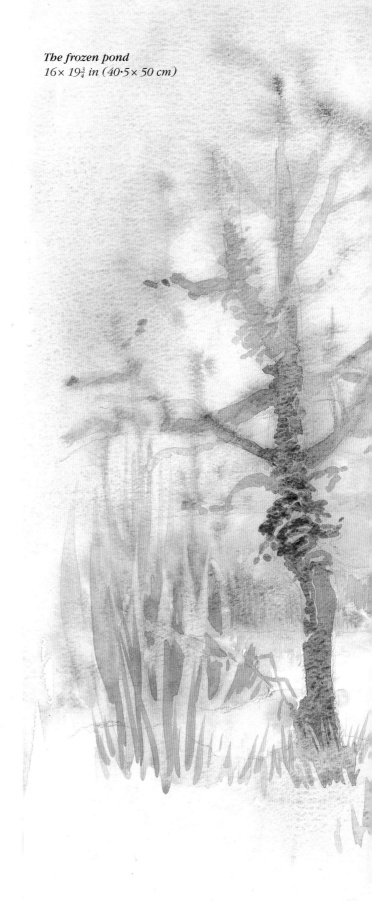

The frozen pond
16 × 19¾ in (40·5 × 50 cm)

K.
Karen Simmons

117

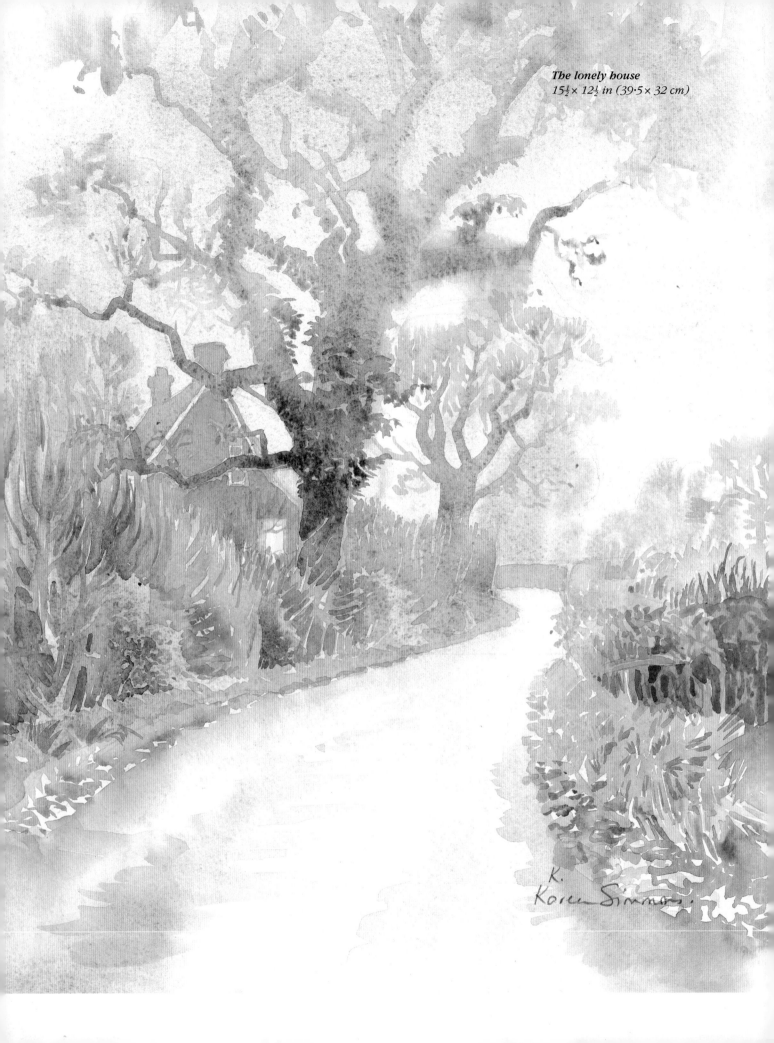

The lonely house
$15\frac{1}{2} \times 12\frac{1}{2}$ in $(39 \cdot 5 \times 32$ cm$)$

The lonely house (opposite)

The house was not really that lonely, but in the fog it was isolated in a world of its own. The one light in the window and the magnificent oak heavily clothed in ivy next to it caught my eye. The road was damp and therefore very light, reflecting the sky.

The grass verge and hedges took on their colours as they emerged from the fog into the foreground. I painted this scene in the same way as *The frozen pond* on pages 116–7, searching out the minor changes of colour and tone. I enjoyed the challenge of this painting, but was glad to get home and warm again.

Snow in my garden (see below and overleaf)

It had snowed heavily in the night, but in the morning the sun shone and the air was still. The lanes around the house were choked with snow. It was all so quiet, with just the occasional plop of snow, loosened from the overburdened branches, falling and denting the deeper snow beneath.

The colours were amazing, and I just had to paint. The view from a window showed me the weeping cherry, marshmallowed with snow against the light and backed by the shadowed pines. With great impatience I started, fearful that the sun would soon melt the snow from the branches.

There was no pre-wetting this time: I started straight in with the cherry tree. Where the snow was translucent I painted in the palest Yellow Ochre; where it lay thickest I shadowed with blue. I varied the colour from Cobalt Blue to a violet-blue by adding Permanent Rose to a turquoise using Cerulean Blue. Leaving dry edges, I wetted a few mounds at a time and then dripped in a little colour well back from the dry margin; the colour would then creep into the damp to give a rounded effect. I needed to keep a very careful watch with regard to the tonal values and really study the grouping of the branches. I painted the branches as they appeared, intermittently.

Next, I painted the pruned roses, each holding its own pompon of snow. When they were dry, I wetted behind them in preparation for painting the snow-capped wall, noting how the snow colour varied from cold to warm. I dropped in the blue and a little dilute Yellow Ochre for the lower curve. This described the reflected light from the sunlit snow beyond the blue shadows.

The snow in the rosebed varied from turquoise to pink to blue to gold. The lawn contained just a hint of yellow in places and, keeping a lot of dry white paper, I added in a few blue shadows.

Detail of **Snow in my garden** *(overleaf). The colours describe sunlight caught in the snow*

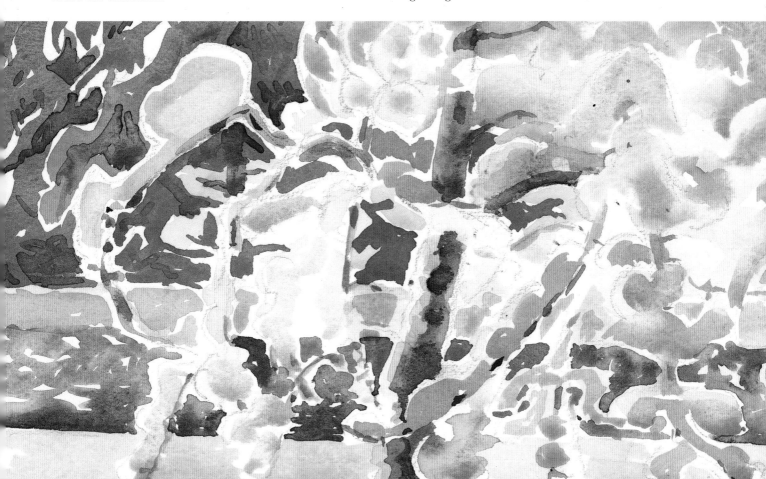

For the snow-rounded steps I pre-wetted the paper except for the pure white areas, and then dropped in the colours again. I used Cobalt Blue and Cerulean Blue, combining Cerulean Blue with Permanent Rose and, once more, just a touch of dilute Yellow Ochre for the reflected light. I strengthened the blue for the branches' shadows with French Ultramarine.

The snow cuff on the hedge beyond was more grey than blue, with a white edge to the top. I painted the hedge itself, which was spattered with caught snow, with French Ultramarine and a little Raw Umber. I scribbled the paint around the little white patches.

I painted the red-brick wall with a mixture of Cadmium Red and Cerulean Blue, keeping the first wash very pale. When this was dry, I swapped my pointed brush for a flat-ended half-inch brush and printed in the brick with the same colour mix, varying the degrees of pink and blue as well as the tone.

I painted the tub with Light Red and then Yellow Ochre. I added a little French Ultramarine, deepening the tone in the shadow but keeping it light where the bright light reflected back from the snow.

The pine trees, behind the cherry tree, weighted with snow and standing against the sun, were amazingly strong in tone. I painted exactly what I saw, using French Ultramarine and a touch of Permanent Rose tempered with some Raw Umber. Keeping the light-edged branches white, I treated the rest as a silhouette, which was how it appeared.

For the silver birches, their filigree caught with snow, I used warmer colours: yellows and Light Red with just light touches of blue. The fresh, sunlit greens of the fir tree on the right showed very clearly, and, keeping the snow areas white, I painted these in, using Cadmium Yellow with a little French Ultramarine. I then shadowed the snow with blue.

For the sky I wet round the trees and into the gaps. I found that to get the amazingly clear aquamarine colour I needed Viridian with a little Cerulean Blue, deepening to Cerulean Blue only, and then up at the top I added a trace of French Ultramarine. While the paper was damp I added another grey tree to the left and one to the right of the painting, behind the green pine tree, using a soft grey.

At this stage I realized that the green tree on the right was far too bright and crisp, and was attracting attention away from the cherry tree. So I wetted the branches – all but the lower ones – and then rolled my brush across, picking up some of the colour. Finally, I washed across a little Yellow Ochre to soften the whole.

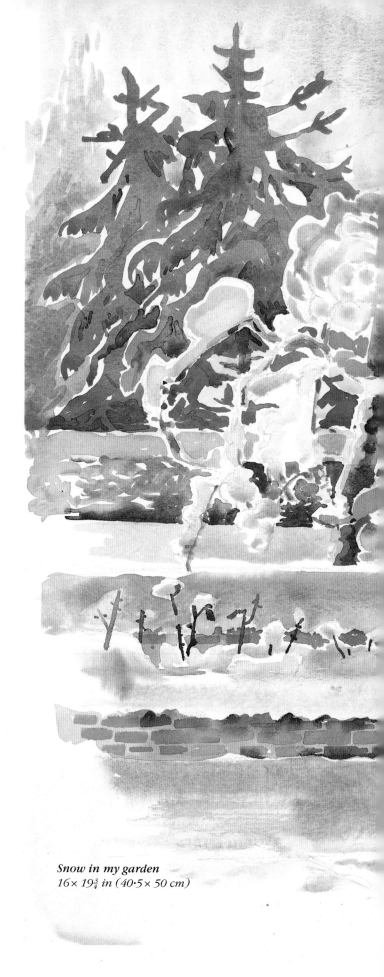

Snow in my garden
16 × 19¾ in (40·5 × 50 cm)

Conclusion

The changing colours describe it all.

To paint or to have a painter's eye adds an extra dimension to living. A painter's response to his or her surroundings is alert and keen, and this awareness enhances each day, whatever the day might bring. An example of this was shown by a dear friend of mine, who was going through a particularly bad patch but remarked on the beauty of the light trapped in a raindrop as it ran down the window-pane. To quote George Perkins Marsh once again, 'Sight is a faculty, seeing is an art.'

In this book I have shared with you my own enjoyment of light falling on different surfaces, revealing colour and describing the shape and form of hill, dale, leaf, stone and flower. I have demonstrated the ways in which I attempt to paint the colours that I see in the landscape. When painting a subject, patches of colour become visible in their own right, making a mosaic of colour, which in turn builds the subject and relates it to its setting.

The more you look, the more you will see – colour awareness can be sharpened with practice. A time of frustration, such as being held up in a traffic jam, or waiting for a bus, can be converted into a soliloquy. What colour would I mix to get the sheen on that wet roof? Or the colour for the underside of that cloud? Thinking in this way ensures that one is never bored.

The painter's eye is an open channel, receiving the image. The painter's heart and soul accept and distil the image. The painter then converts the vision to create a new image. The cycle is completed when the painting is seen by another, who in turn recognizes and responds to the vision. The idea is the 'story', and the craft is to tell that 'story' to another successfully in visual terms.

This book describes some of the practical and simple foundation methods that I have found useful over the years, and may help to ease the translation of your ideas into visual reality. It is about colour: seeing colour, mixing colour and applying colour, not as isolated activities but in the relation of the colours to each other. The subjects available to the painter are wide-ranging, seen in a variety of lights, at different times of the day, at different times of the year and even in different climates. The changing colours describe it all.

(Opposite) **The bush of the rising moon**
16¼ × 13 in (41 × 33 cm)

K.
Karen Simmons

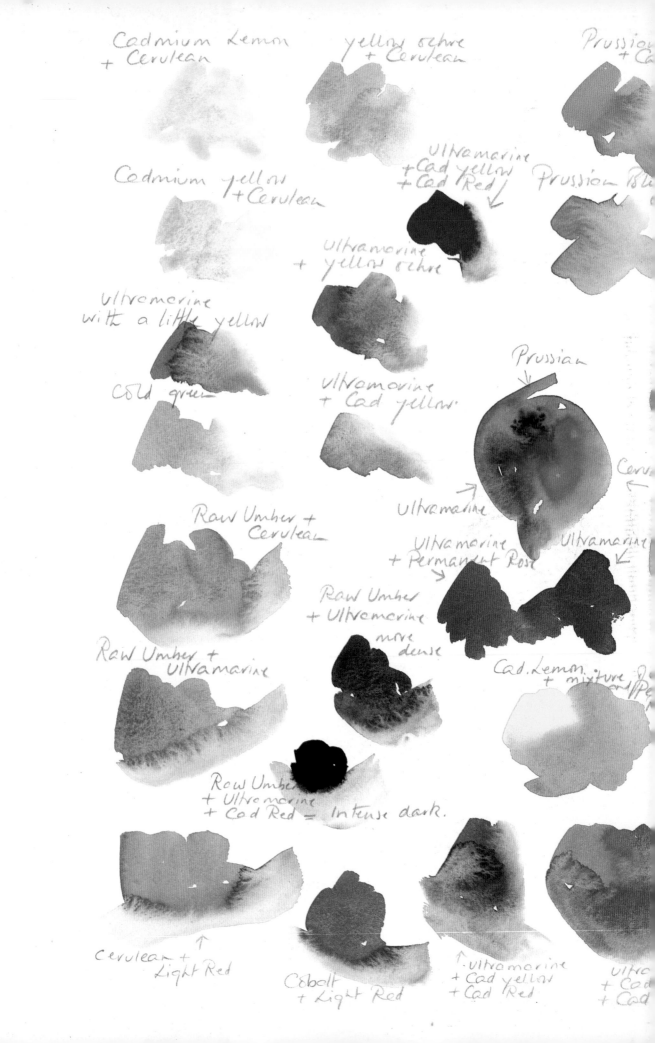

Cadmium Lemon
+ Cerulean

yellow ochre
+ Cerulean

Prussian
+ Ce

Ultramarine
+ Cad yellow
+ Cad Red

Prussian Blu

Cadmium yellow
+ Cerulean

Ultramarine
+ yellow ochre

ultramarine
with a little yellow

Prussian

Cold green

Ultramarine
+ Cad yellow

Ceru

Ultramarine

Raw Umber +
Cerulean

Ultramarine
+ Permanent Rose

Ultramarine

Raw Umber
+ Ultramarine
more
dense

Cad. Lemon
+ mixture P

Raw Umber +
Ultramarine

Raw Umber
+ Ultramarine
+ Cad Red = Intense dark.

Cerulean +
Light Red

Cobalt
+ Light Red

ultramarine
+ Cad yellow
+ Cad Red

ultra
+ Cad
+ Cad